Dean Dexter
Ambrose

H STREET, NEW YORK 3, N.Y. GRamercy 3-5785

Arty Levin
Barbara Moraff

Dodie M

Jack Knowles
Walnut 5 6500

DECEMBER INVITATIONAL ANNUAL

Area 80 East 10 Stre
Brata 89 East 10 Stre

Jack Kerouac
7 Arts Coffee Shop
82 Club 2 d Ave
Eigh The Cedar Chinatown
Half Five Spot

Village Gate — (BM music)

Noragon — art gallery — Sunday aft
GR5 5232 music etc —

The Couch — (tourist)

Living Theatre — poetry + jazz
jack spicer

ted Joans
22 Astor Place
AL 4-0796 studio
EL 1-5167 home

Bizarre — coffee house

PHOTOGRAPHER: Burt Glinn　　　　　SUBJECT: Bohemians

CONDITIONS: Assignment for Esquire　　　STORY NUMBER: 57-1

Take	B/W	Color	Captions	Rec'd from & date
1	6 rolls, 1 setcts			Feb 11
2	5 rolls, 1cts	yes		
3	5 rollslcts			

Sent to	Date	Prnts	Caps	Color	Cntct	Negs	Dated	Prnts	Caps	Color	Cntct	Negs	ID sat ue	SP a r l i ce
Felker	2-26-57			128-35mm			8 OCT '57			Color returned				
Esquire		112			8									
Felker								15(8x10)						
Esquire	6-13				49		?	23(11x14)			49			

the
beat
scene

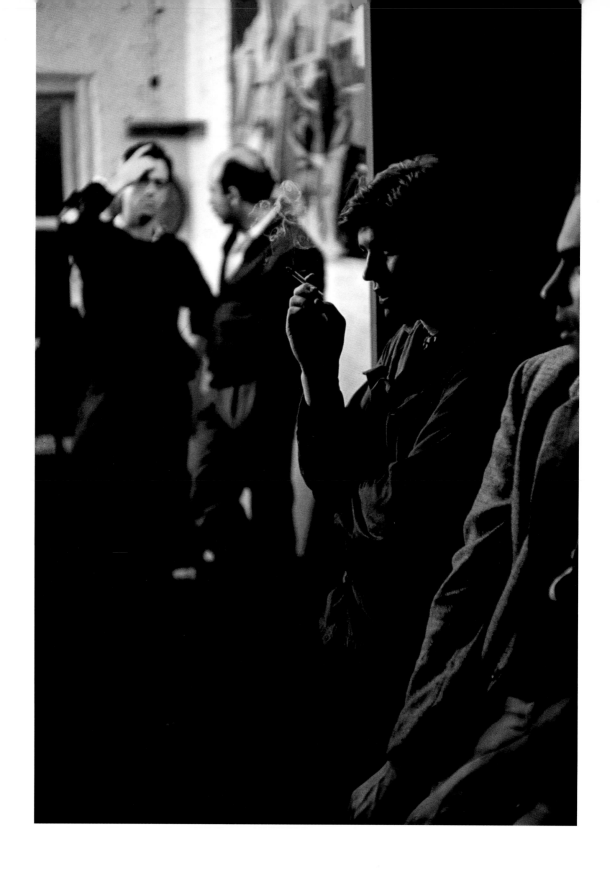

A Beatnik party.

the beat scene

photographs by burt glinn
essay by jack kerouac

R|A|P

REEL ART PRESS

photographs by burt glinn

essay by jack kerouac

edited by michael shulman and tony nourmand

additional text by sarah stacke and michael shulman

art direction by graham marsh

layouts by jack cunningham

text edited by alison elangasinghe

editorial assistance by rory bruton

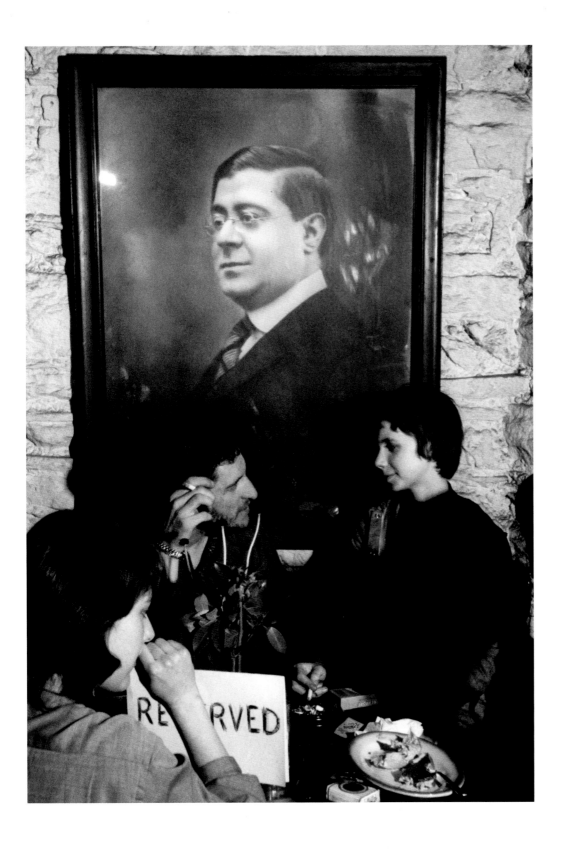

Poet Ray Bremser after a reading at
The Gaslight Cafe on MacDougal Street.

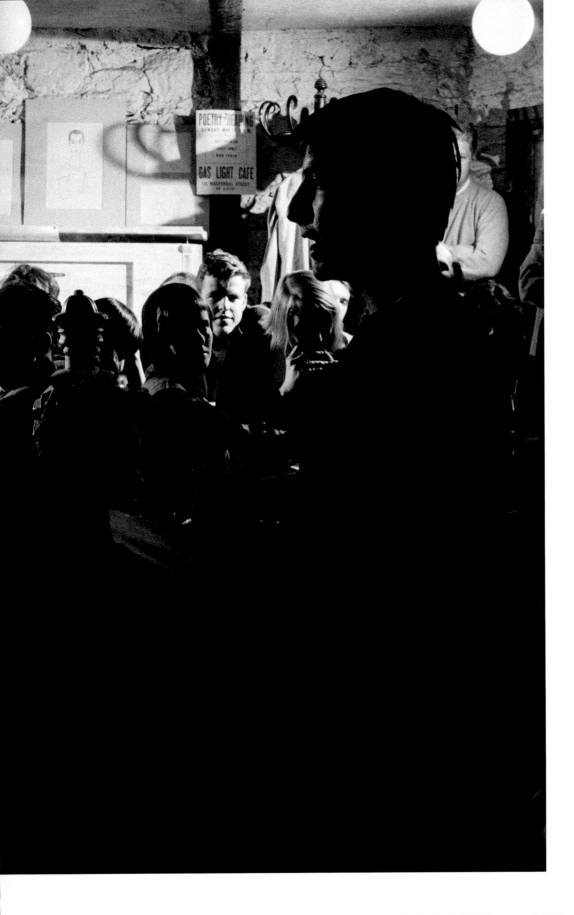

Poet Bob Ludin reads his poetry at The Gaslight Cafe.

contents

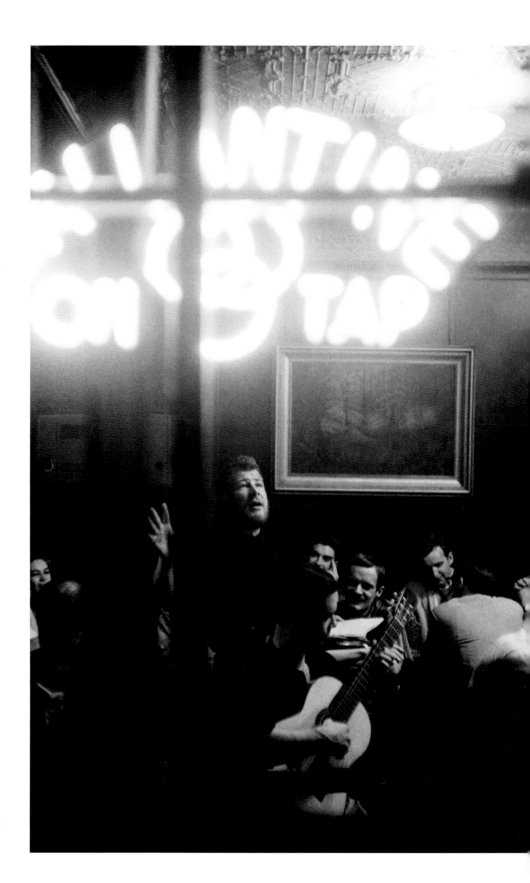

Poet Hugh Romney reads poetry
at the White Horse Tavern.

burt glinn 1959
by sarah stacke

THE YEAR 1959 was a defining chapter for Burt Glinn, then a 33-year-old photographer with Magnum Photos. On the first of January, recovering from New Year's Eve revelry and a break of dawn flight, Burt arrived in Havana to photograph the Cuban Revolution. For ten days he covered the mayhem, joy and seduction of Fidel Castro's unhurried public descent from the island's eastern mountains and grandiose entrance into Havana. The crowds were so euphoric in the capital that Burt was lifted out of his shoes along the Malecón. He made his famed image of Castro entering Havana, the one in which every angle of limb and gun barrel screams triumph as brilliantly as a firework, in his socks.

Twelve months later, Burt left behind an unparalleled story list. It included iconic images of a sultry Elizabeth Taylor and a spirited Katharine Hepburn on the set of *Suddenly Last Summer*; a contemplative Sammy Davis, Jr. leaning against a Manhattan window, the Midtown skyline softly forming, or fading, outside; the back of Nikita Khrushchev's balding head as he contemplated the composure of America's 16th president atop the Lincoln Memorial. In England, Burt shot the debut party for young Lindy Guinness at Belvoir Castle and parents day at Eton. In Switzerland he photographed the debauchery of St. Moritz's glamorous clientele. He also traveled to Israel, Italy, the Netherlands and Spain on assignment, among other destinations.

And in New York City he chronicled leading members of the Beat Generation—writers Jack Kerouac, Gregory Corso, LeRoi Jones and publisher Barney Rossett—in the smoky cafes, basement-bars and apartments of Greenwich Village and Times Square. Eudora Welty said that photographers must "be sensitive to the speed, not simply of the camera's shutter, but of the moment in time." The social movements, as well as the gestures and particularities of individuals to which Burt paid attention, speak to this quality. Burt's images of the Beats, almost always made at night, arrange arms in motion, burning cigarettes, berets, typed pages and earnest conversations inside the frame. The compositions render the culture of nonconformity and spontaneous expressionism embraced by the Beats.

Burt was my first mentor. It's been nearly 20 years since he hired me to help digitize his massive archive. The scene in Burt's Upper West Side studio was always chaotic. Binders brimmed with negatives and notes, light tables were strewn about and stacks of file cabinets filled with slides and prints lined the walls. It was the result of nearly six decades of nonstop work.

There are occurrences in life that cause a dramatic change of direction, a 90-degree turn. Meeting Burt, his wife Elena and son, Sam, was one of those events for me. The Glinns introduced me to New York, where I'm still based, and ushered a deep appreciation of the arts. They saw more in me than I saw in myself and were patient as I discovered my voice. As a photographer and person Burt demonstrated kindness and the importance of doing things well. In my work as a photojournalist I often think about what approach Burt might have taken when navigating the visual, ethical and social questions that arise in this line of work.

I visit Elena often in East Hampton, where she now lives. Burt spent his last years there and the sun-filled studio they attached to the house remains wonderfully lawless. Every surface is covered with a rotating selection of family photographs and images made by Burt or his venerated Magnum colleagues. How fortunate we are to have access to this photographic treasure chest of countless celebrated people and many of the most momentous and beautifully quotidian happenings of the 20th century's second half.

burt and the beats
by michael shulman

BURT GLINN, the legendary Magnum photographer, who joined the agency in 1951, was a master of observation of all aspects of life. Like many photojournalists who worked for the picture magazines in the 1950s, he covered a wide range of subjects in a given year, and 1957-1960 were not exceptions. In the same year that he shot the first story of the New York Beat Scene in 1957 for *Esquire*, he photographed Queen Elizabeth II on her visit to New York City, the desegregation of Little Rock High, which required the National Guard to protect nine African American students against an angry mob, and trips to Jerusalem and London. 1959, covering Jack Kerouac, Gregory Corso, and their fellow Beats in New York City, for *Holiday* magazine, which originally featured the essay by Kerouac that is contained here, began with Burt rushing to Cuba on New Year's Day to document the beginning of the Revolution. In addition to photographing on the set of the film *Suddenly Last Summer*, he shot a brilliant feature on Sammy Davis, Jr. There were trips to Switzerland and Spain, England again, and Nikita Khrushchev's visit to the US. 1960, when Burt shot the Beats in San Francisco for *Holiday* magazine, was also a year for the South Pacific, *Toys in the Attic* on Broadway, Phil Silvers on TV, and England yet again.

What his coverage of all these diverse subjects had in common was his unerring way of getting inside the emotional truth of the situation. This was especially true in his stories on the Beats. He had a wry detachment but a grudging respect for them, as seen in his sympathetic photos of a culture that was an outspoken reaction and rejection of the status quo.

Burt's coverage of the Beats, usually thought of as stark black and white, now also seen in many previously unseen color images, seem like a revelation. Their discovery (or uncovering) happened when Tony Nourmand and I were working on a Burt Glinn retrospective book (due sometime in the near future). We were in Elena Glinn's studio in Long Island, going through his color archive, and innocently asked her "What else do you have of the Beats that we haven't seen before?", when she proceeded to pull out boxes and boxes of slides. Holding the first one up to the light, we both screamed with excitement, seeing amazing photos from long ago in a contemporary light. The vivid colors, seen through Burt's painterly eye, give us a new insight on the reality of the Beat daily life. There is also no shortage of great noir-ish black and white of Kerouac, Corso, Ginsberg, LeRoi Jones and their contemporaries in New York. Then there's the San Francisco Scene, including City Lights bookstore owner and publisher Lawrence Ferlinghetti, galleries and cafes, and a wild party at Verve Records cover artist David Stone Martin's loft, with swingers literal and metaphorical.

Many of the photos herein are previously unseen, and are from the Magnum Photos and Burt Glinn archive, and show the depth of his unmatched talent. We are pleased to present them, along with the famous iconic frames, to bring them to light once again.

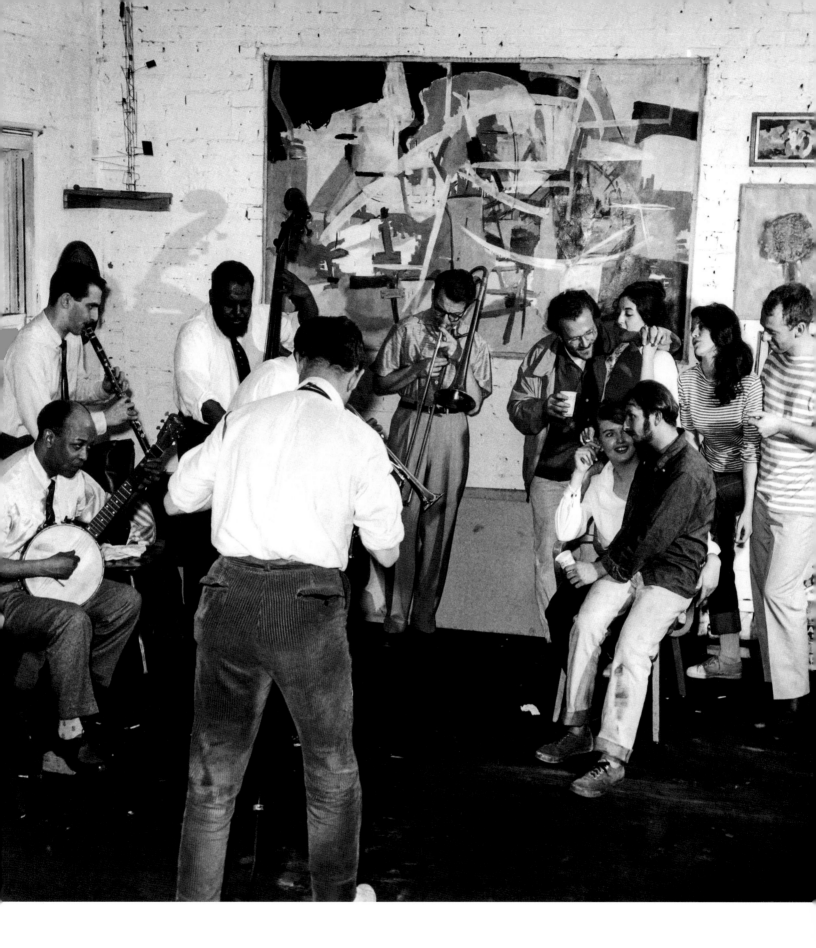

Burt Glinn photographing a "Rent a Beatnik"
 party for Holiday magazine. New York, May 24, 1959.

and this is the beat nightlife of new york
by jack kerouac

THE BEAT NIGHTLIFE of New York strangely has nothing to do with nightclubs or spending money and yet it is a complete nightlife in the truest sense. Take, for example, this typical evening among the characters:

Emerging from the Seventh Avenue subway on 42nd Street, passing the john, which is the beatest john in New York, it smells awful and you never can tell if it's open or not; usually it's got a big chain in front of it saying it's out of order, or else it's got some white haired decaying monster slinking outside, a john which all seven million people in New York City have at one time passed and taken strange notice of—past the new charcoal-fried-hamburger stand, Bible booths, operatic jukeboxes, and a seedy underground used-magazine store next to a peanut-brittle store smelling of subway arcades—usually pausing a half-hour to go through old copies of *National Geographic* and look at 1930's girlie magazines with their heads of girls on the covers cut off by razors (titles are sliced off for commercial purposes so they can re-sell)—here and there a used copy of that old bard Plotinus sneaked in with the remainders of collections of German high school textbooks—where they sell long ratty-looking hotdogs (no, actually they're quite beautiful, particularly if you're coming from the Bronx and haven't got 15 cents and are looking for someone in Bickford's Cafeteria who can lay some smash on you.)

Coming up that stairway, people standing there for hours and hours drooling in the rain, soaking wet umbrellas, lots of boys in dungarees scared to go into the Army standing halfway up the stairway in the iron steps waiting for God Who knows what, certainly among them some romantic heroes just in from Oklahoma, with ambitions to end up yearning in the arms of some unpredictable sexy young blonde in a penthouse in the Empire State Building—some of them probably stand there dreaming of owning the Empire State Building by virtue of a magic spell which they've dreamed up by a creek in the backwoods of a ratty old house on the outskirts of Texakarna.—Ashamed of being seen going into the dirty movie (what's its name? the Rialto?) across the street from the *New York Times*— The lion and the tiger passing, as Tom Wolfe used to say about certain types passing that corner.

Leaning against that cigar store with a lot of telephone booths. Where you make beautiful telephone calls looking out into the street and it gets real cozy in there when it's raining outside and you like to prolong the conversation, on the corner of 42nd and Seventh, who do you find? Basketball teams? Basketball coaches? All those guys from the rollerskating rink go there? Cats from the Bronx again, looking for some action, really looking for romance. Strange duos of girls coming out of dirty movies? Did you ever see them? Or bemused drunken businessmen with their hats tipped awry on their graying heads staring catatonically upwards at the signs floating by on the Times Building, huge sentences about Khrushchev reeling by, the populations of Asia enumerated in flashing lightbulbs, always five hundred periods after each sentence. Suddenly a psychopathically worried policeman appears on the corner and tells everybody to go away. This is the center of the largest city the world has ever known and this is what beatniks do here.

"Standing on the street corner waiting for no one is Power," sayeth poet Gregory Corso.

Instead of going to nightclubs—if you're in a position to make the nightclub scene (most

A nightlife worlds away from costly
 nightclubs flourishes in pockets of
pleasure scattered through lower Manhattan.

Two Beatniks eat two hamburgers in "Grant's" famed

 24-hour-a-day hotdog-hamburger-oyster eatery of New York where

even the food is "Beat". It is right in the heart of noisy Times Square.

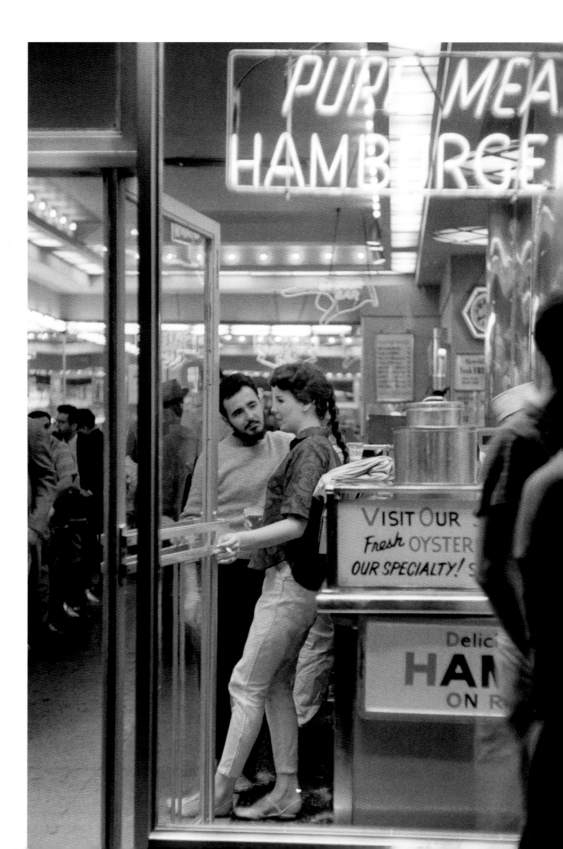

beatniks rattle empty pockets passing Birdland)—how strange to stand on the sidewalk and just watch that weird eccentric from Second Avenue looking like Napoleon going by feeling cookie crumbs in his pocket, or a young 15-year-old kid with a bratty face, or suddenly somebody swishing by in a baseball hat (because that's what you see), and finally an old lady dressed in seven hats and a long ratty fur coat in the middle of the July night carrying a huge Russian woollen purse filled with scribbled bits of paper which say "Festival Foundation Inc., 70,000 Germs" and moths flying out of her sleeve—she rushes up and importunes Shriners—And dufflebag soldiers without a war—Harmonica players off freight trains—Of course there are the normal Newyorkers, looking ridiculously out of place and as odd as their own neat oddity, carrying pizzas and *Daily Newses* and headed for brown basements or Pennsylvania trains—W.H. Auden himself may be seen fumbling by in the rain—Paul Bowles, natty in a Dacron suit. Passing through on a trip from Morocco, the ghost of Herman Melville himself followed by Bartleby the Wall Street Scrivener and Pierre the ambiguous hipster of 1848 (followed by Villon) out on a walk—to see what's up in the *Times*—Let's go back to the corner newsstand. "SPACE BLAST…. POPE WASHES FEET OF POOR"—

Let's go across the street to Grant's, our favored dining place. For 65 cents you get a huge plate of fried clams, a lot of French fried potatoes, a little portion of cole slaw, some tartar sauce, a little cup of red sauce for fish, a slice of lemon, two slices of fresh Rye bread, a pat of butter, another ten cents brings a rare glass of birch beer… What a ball it is to eat there! Migrations of Spaniards chewing on hotdogs standing up, leaning against big pots of mustard. Ten different counters with different specialties. 10¢ cheese sandwiches, two liquor bars for the Apocalypse, oh yeah and great indifferent bartenders—and cops that stand in the back getting free meals—Drunken saxophone players on the nod—Lonely dignified ragpickers from Hudson Street supping soup without a word to anybody, with black fingers, woe—Twenty thousand customers a day—Five thousand on rainy days—One hundred thousand on snowy days—Operation twenty-four hours a night—Privacy: supreme, under a glary red light full of conversation. Toulouse-Lautrec sketching in the corner with his hunchback and cane. You can stay there for five minutes and gobble up your food, or else stay there for hours having insane philosophical conversation with your buddy and wondering about the people. "Let's have a hotdog before we go to the movie!" and you get so high in there you never got to the movies, because it's better than a show about Doris Day on a holiday in the Caribbean.

"But what are we gonna do tonight? Marty would go to a movie but we're going to connect for some junk. Let's go down to the Automat."

"Just a minute, I've got to shine my shoes on top of a fire hydrant."

"You wanta see yourself in the fun mirror?"

"Wanta take four pictures for a quarter? Because we're on the eternal scene. We can look at the picture and remember it when we're wise old white-haired Thoreaus in cabins."

"Ah the fun mirrors are gone, they used to have fun mirrors here."

"How about the Laff Movie?"

"That's gone too."

"They got the flea circus."

"They still got donzinggerls?"

"The burlesque is gone, millions and millions of years ago."

"Shall we go down by the Automat and watch the old ladies eating beans or the deaf-mutes that can't talk that stand in front of the window there and you watch 'em and try to figure the invisible language as it flees across the window from face to face and finger to finger…? Why does Times Square feel like a big room?"

Across the street is Bickford's, right in the middle of the block under the Apollo Theater marquee and right next door to a little bookshop that specializes in Haveloc Ellis and Rabelais, with thousands of sexfiends leafing at the bins. Bickford's is the greatest stage on Times Square: many people have hung around there for years, man and boy, searching, God alone knows for what, maybe some angel of Times Square who would make the whole big room home, the old homestead… civilization needs it. What's Times Square doing there anyway? Might as well enjoy it. Biggest city the world has ever seen. Have they got a Times Square on Mars? What would the Blob do on Times Square? Or St. Francis?

A girl gets off a bus in the Port Authority Terminal and goes into Bickford's, Chinese girl, sits down, red shoes, with a cup of coffee, looking for daddy.

Strange how Bickford's has become a kind of Mecca for tablesful of arguing young palefaced juveniles dreaming of keeping a car and buying nice clothes in Jamaica Long Island, one of them just got out of the Army by putting ten copper pennies under his tongue. "It gives you a fever, they think you're weak, can't lift a rifle." You can get hungup there with a dozen cups of tea having big conversations with these kids sitting around at the tables, under the neon light, combinations of Negroes and whites, girls with fat juicy girdles who have unbelievable sincerity and enduring charm to stay up all night with their knees spread leaning against the wall in a chair chewing bubblegum. And also luscious brunette dolls with long eyelashes and purple eye-makeup looking for someone to kick their shoes off in the Dixie or the Roxy Hotels. For love—

There's a whole floating population around Times Square that has always made Bickford's their headquarters day and night. In the old days of the beat generation some poets used to go in there to meet the famous character "Hunkey" who used to come in and out in an oversized black raincoat and a cigarette holder, looking for somebody to lay a pawnticket on—Remington typewriter, portable radio, black raincoat, to score for some toast so he can go uptown and get in trouble with the cops or any of his boys—Also a lot of stupid gangsters from 8th Avenue used to cut it in…maybe they still do—The ones from the early days are all in jail or dead. Now the poets just go there, sit silently and smoke a peace pipe, looking for the ghost of Hunkey, or his boys, and dream over the fading cups of tea.

The beatniks make the point that if you went there every night and stayed there you could start a whole Dostoevsky season on Times Square by yourself and meet all the midnight newspaper peddlers and their hangups and families and woes, religious fanatics who would take you home and give you long sermons over the kitchen table about the "new apocalypse" and similar ideas: "My

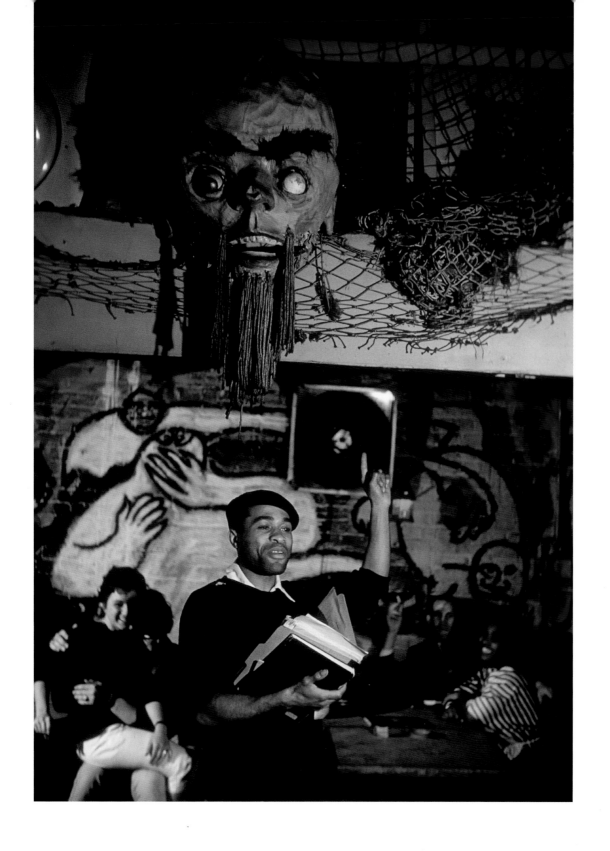

At the Bizarre, one of the many coffeehouses
that have sprung up in the Greenwich Village,
poet Ted Joans recites his poems before an interested
but informal audience.

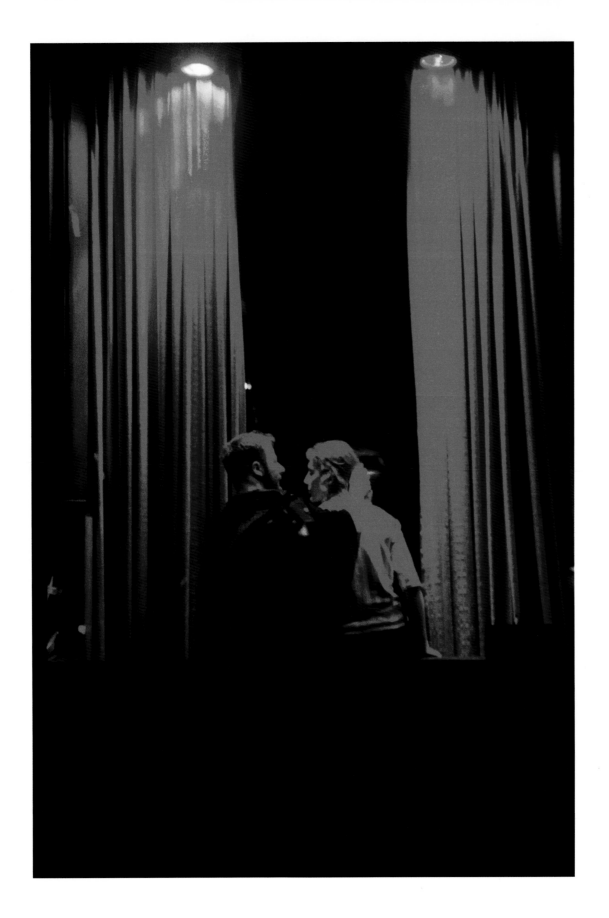

Hugh Romney and a friend at the Half Note club on Hudson Street, New York.

Baptist minister back in Winston-Salem told me the reason that God invented television was that when Christ comes back to Earth again, they shall crucify Him right on the streets of this here Babylon and they gonna have television cameras pointin down on that spot and the streets shall run with blood and every eye shall see."

Still hungry, go, cut, down to the Oriental Cafeteria—"favored dining spot" also—some nightlife—cheap—and eat big olive oily lambs' shanks with Greek rice for 90¢, down in the basement across the street from the Port Authority Monolith Bus Terminal on 40th Street. Oriental zig-zag tunes on the jukebox.

Depends how high you are by now—assuming you've picked up on one of the corners—say 42nd Street and 8th Avenue, another lonely haunt spot you can meet people at, near the great Whelan's sodafountain-drugstore-cigarstore—negro whores, ladies limping in Benzedrine psychosis—Across the street you can see the ruins of New York already started—The Globe Hotel being torn down there, an empty tooth-hole right off 42nd Street—and the green McGraw-Hill building gaping up in the sky, higher than you'd believe—lonely all by itself down towards the Hudson River where freighters wait in the rain for their Montevideo limestone—

Might as well go on home. It's getting old. Or: "Let's make the Village or go to the Lower East Side and play Symphony Sid on the radio—or play our Indian records—and eat big dead Puerto Rican steaks—or lung stew—see if Bruno has slashed any more car roofs in Brooklyn—though Bruno's gentled now, maybe he's even written a new poem."

Or look at television. Nightlife—Oscar Levant talking about his melancholia.

The Five Spot, on 5th Street and Bowery, sometimes features Thelonious Monk on piano and you go on there if you know the proprietor and sit down at the table free with a beer, but if you don't know him you can sneak in and stand by the ventilator and listen. Always crowded weekends. Monk cogitates with deadly abstraction, clonk, and makes a statement, huge foot beating delicately on the floor, head turned to one side listening, entering the piano.

"How about a beatnik coffee shop?"

"College kids don't suffer yet."

"How about Mabel Liston's sextet up at Small's Paradise
in Harlem?"

"Half-hour subway ride—wow."

The nightclubs of Greenwich Village known as the Half Note, the Village Vanguard, the Café Bohemia, also feature jazz (Lee Konitz, J.J. Johnson, Miles Davis) but you've got to have mucho money and it's not so much that you've got to have mucho money but the sad commercial atmosphere is killing jazz and jazz is killing itself there, because jazz belongs to open, joyful ten-cent beer joints, as in the beginning.

There's a big party at some painter's loft, wild loud flamenco on the phonograph, the girls suddenly become all hips and heels and people try to dance between their flying hair. Men go mad and start tackling people, flying wedges of whole groups hurtle across the room, men grab men around the

knees and life them nine feet from the floor and lose their balance and nobody gets hurt, blonk. Girls are balanced hands on men's knees and their skirts falling and revealing frills on their thighs. Finally everyone dresses to go home and the host says dazedly, "You all look so *respectable*."

Or somebody just had an opening (Miles Forst just opened a show at the Hansa Gallery uptown) or there's a poetry reading at the Living Theater, or at the Gaslight Café, or at the Seven Arts Coffee Gallery up around Times Square (9th Avenue and 43rd Street, amazing spot) (begins at midnight Fridays) where afterwards everybody rushes out to the old wild bar. Or else a huge party at LeRoi Jones's—he's got a new issue of *Yugen* magazine which he printed himself on a little cranky machine and everybody's poems are in it, from San Francisco to Gloucester Mass., and only costs 50 cents. Historic publisher, secret hipster of the trade. LeRoi's getting sick of parties, everyone's always taking off his shirt and dancing, three sentimental girls are crooning over poet Raymond Bremser, Gregory Corso is arguing with the *New York Post* reporter saying "But you don't understand Kangaroonian weep! Forsake thy trade! Flee to the Enchenedian Islands!"

Let's get out of here, it's too literary. Let's go get drunk on the Bowery or eat in Chinatown at Hong Fat's those long noodles and tea in glasses. What are we always eating for? Let's walk over the Brooklyn Bridge and build up another appetite.

How about some okra on Sand Street?

Shades of Hart Crane!

Ah let's go back to the Village and stand on the corner of 8th Street and Sixth Avenue and watch the intellectuals go by. AP reporters lurching home to their basement apartments on Washington Square, lady editorialists with huge German police dogs breaking their chains, lonely dikes melting by, unknown experts on Sherlock Holmes with blue fingernails going up to their rooms to take scopolamine, a muscle-bound young man in a cheap, gray German suit explaining something weird to his fat girlfriend, great editors leaning politely at the newsstand buying an early edition of the *Times*, great, fat, furniture movers out of 1910 Charlie Chaplin films coming home with great bags full of chop suey (feeding everybody), Picasso's melancholy harlequin now owner of a print and frame shop musing on his wife and newborn child lifting up his finger to a taxi, rolypoly recording engineers rush in fur hats, girl artists down from Columbia with D.H. Lawrence problems picking up 50-year-old men, old men in the Kettle of Fish, and the melancholy spectre of New York Women's prison that looms high and is folded in silence as the night itself—at sunset their windows look orange—poet e.e. cummings buying a package of cough drops in the shade of that monstrosity. If it's raining you can stand under the awning in front of Howard Johnson's and watch the street from the other side.

Beatnik Angel Peter Orlovsky in the supermarket five doors away buying Uneeda Biscuits (late Friday night), ice cream, caviar, bacon, pretzels, soda-pop, *TV Guide*, Vaseline, three toothbrushes, chocolate milk (dreaming of roast suckling pig), buying whole Idaho potatoes, raisin bread, wormy cabbage by mistake, and fresh-felt tomatoes and collecting purple stamps. Then he goes home broke and dumps it all on the table, takes out a big book of Mayakovsky poems, turns on the 1949 television set to the horror movie, and goes to sleep.

And this is the beat nightlife of New York.

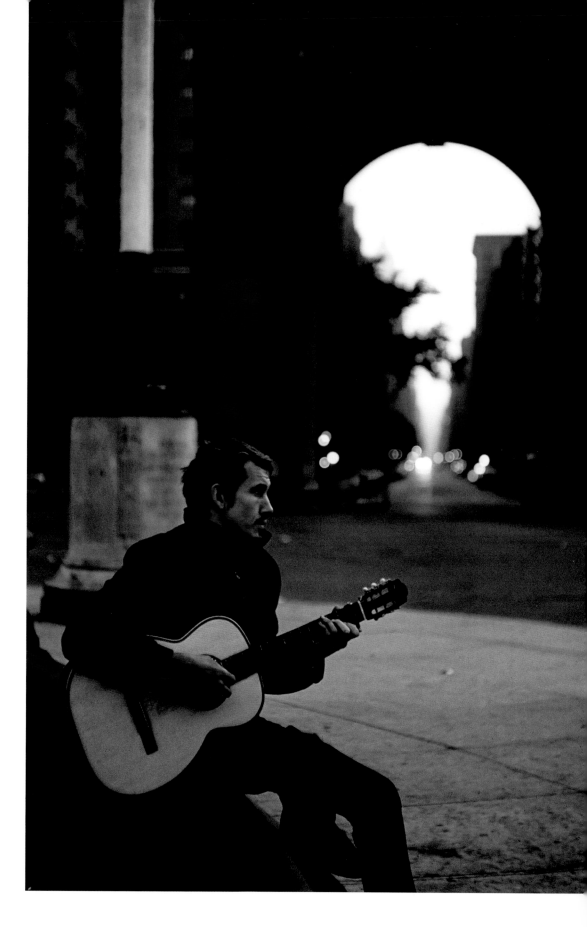

A streak of loneliness runs through these gaudy evenings
 on the town. Tonight, a lone guitarist
 plays the last music of the night.

for burt
love elena

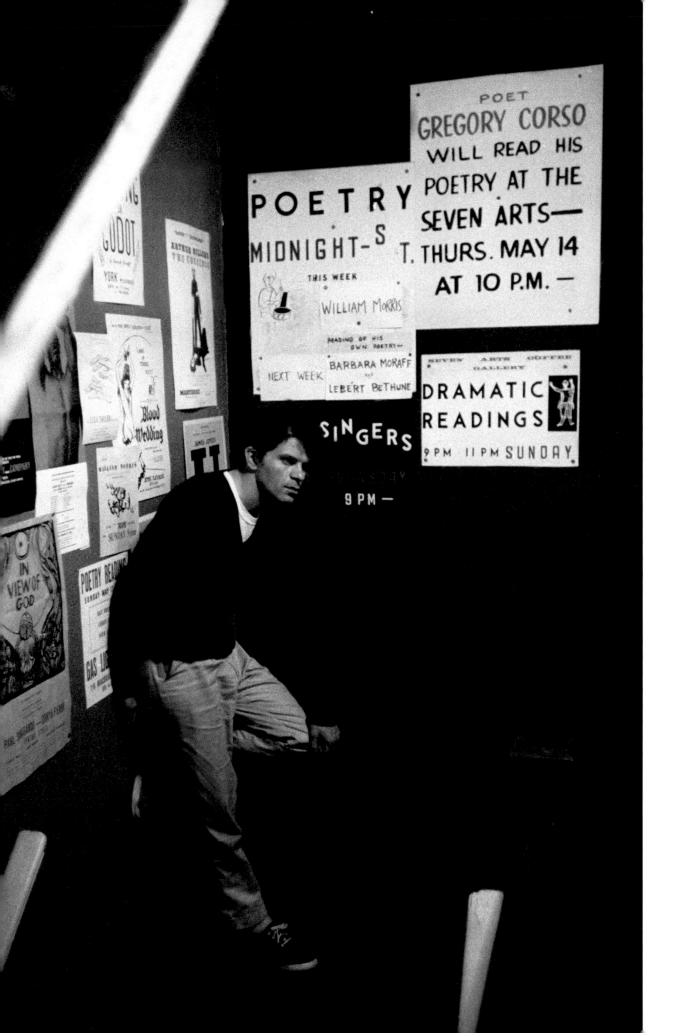

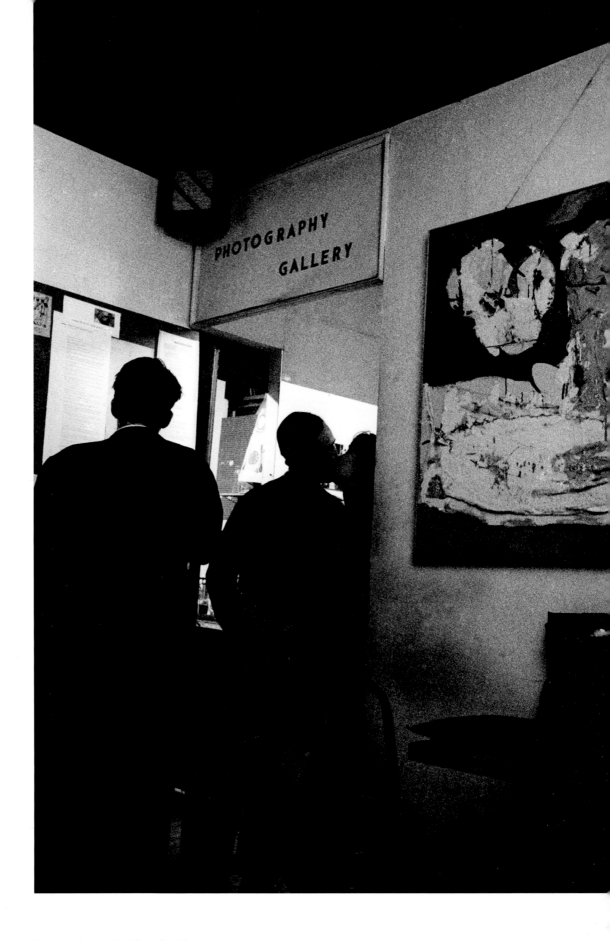

Seven Arts Coffee Gallery.

the beat scene

1957-1960
Photographs and text by
Burt Glinn

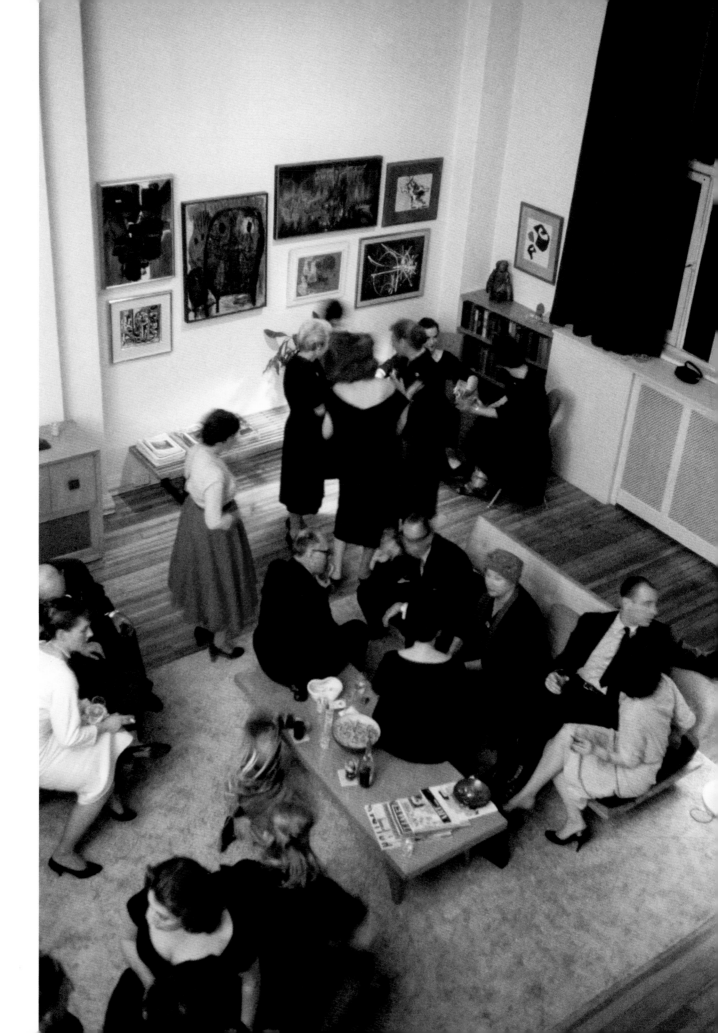

upper
and
lower
bohemians
1957

Surrounded by modern art, Upper Bohemians mingle at a party given
by photographer Arnold Newman. Upper Bohemians
act as a bridge between creative artists and the general public.

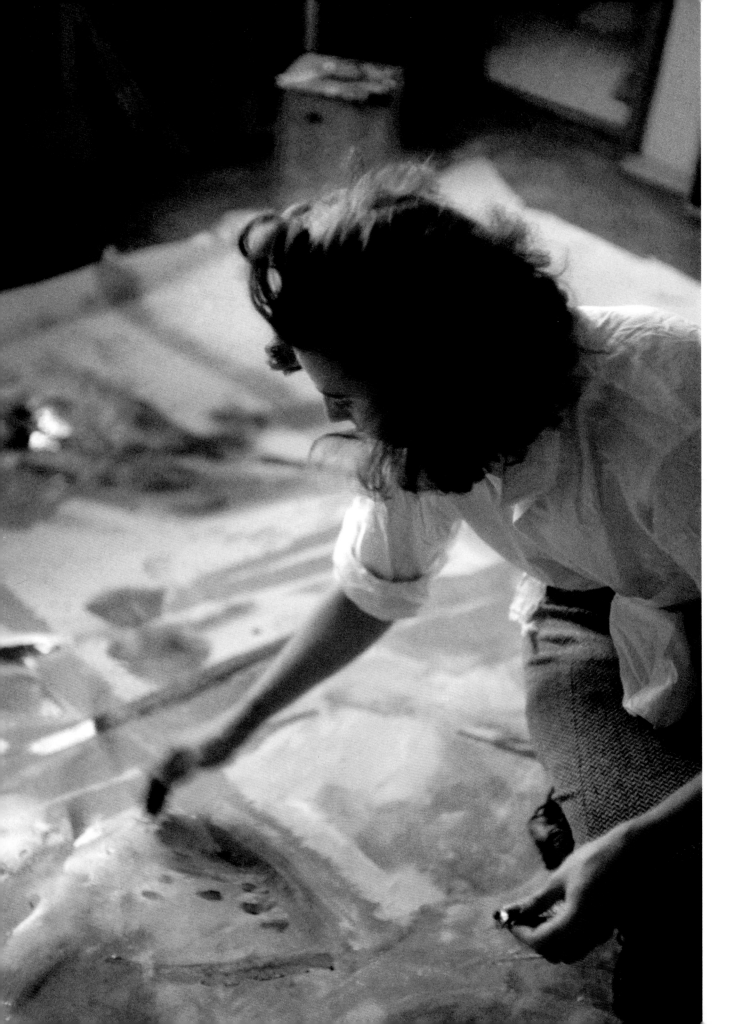

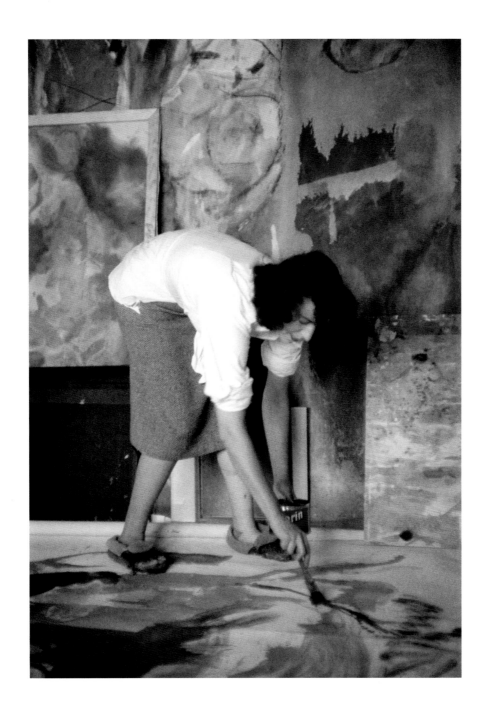

Young Helen Frankenthaler in her studio working
on an abstract expressionist painting.
She recently sold paintings to the Whitney Museum
and the Museum of Modern Art.
(Overleaf) with abstract expressionist sculptor
and painter David Smith.

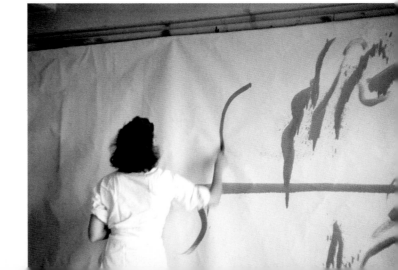

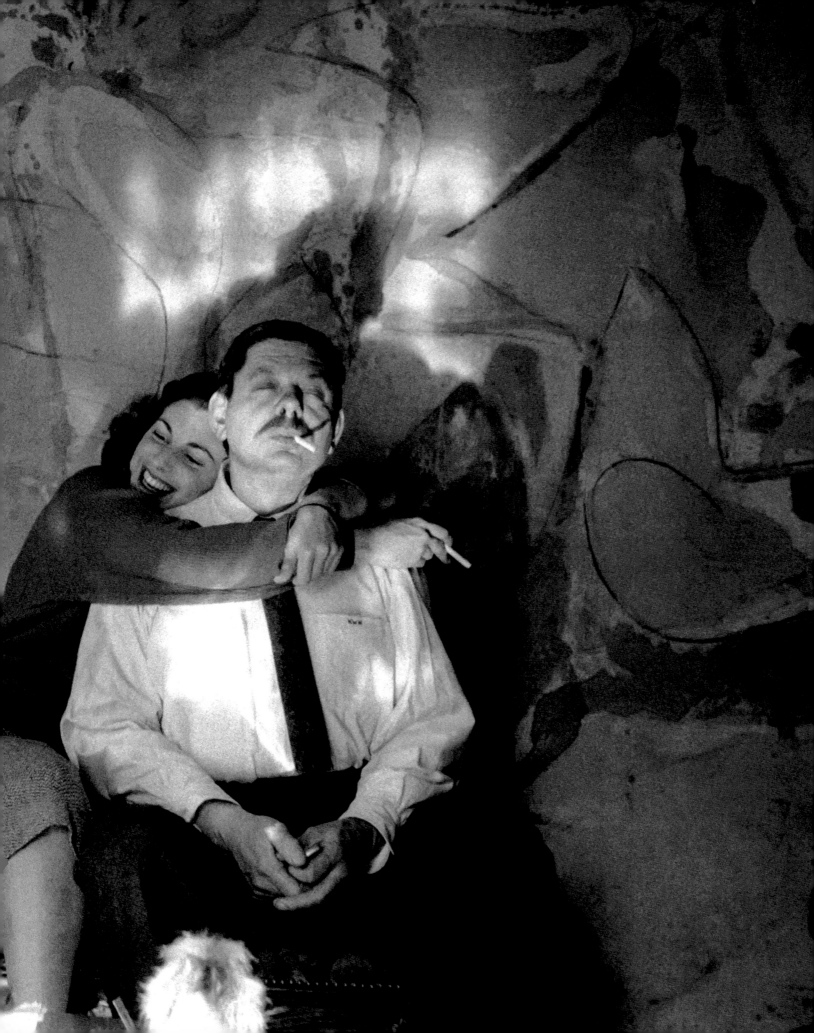

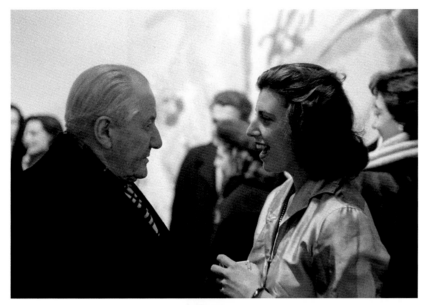

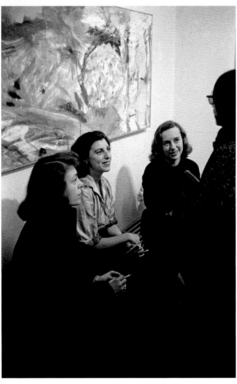

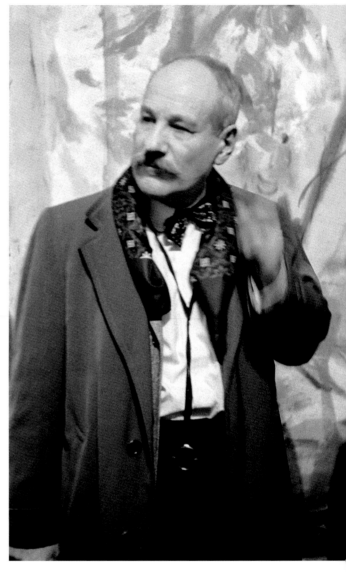

Opening of Frankenthaler's latest exhibition.
Painters Hans Hofmann (top), Barnett Newman (right)
and (bottom, left to right) Joan Mitchell,
Helen Frankenthaler, and Grace Hartigan.

Museum of Primitive Art opening. Mrs. Bernard Reis,
 wife of an accountant, joins sculptor Jacques Lipchitz.

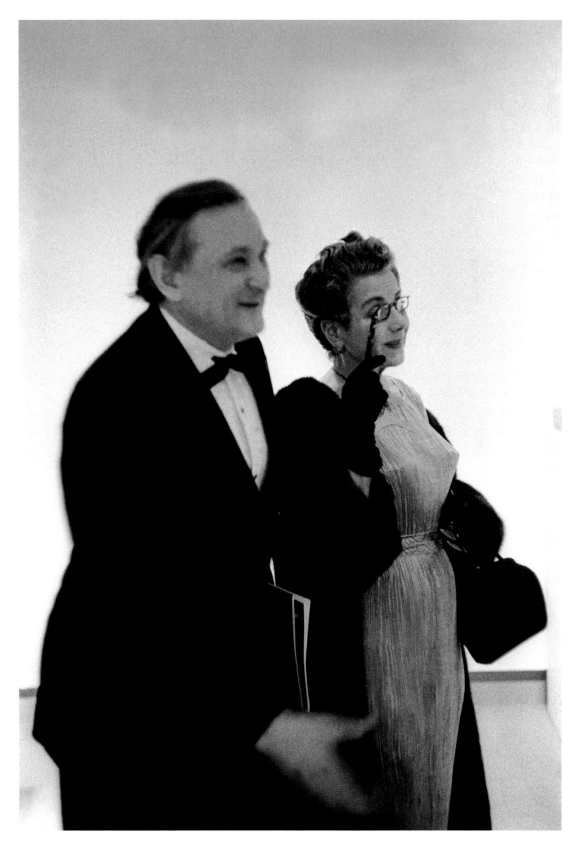

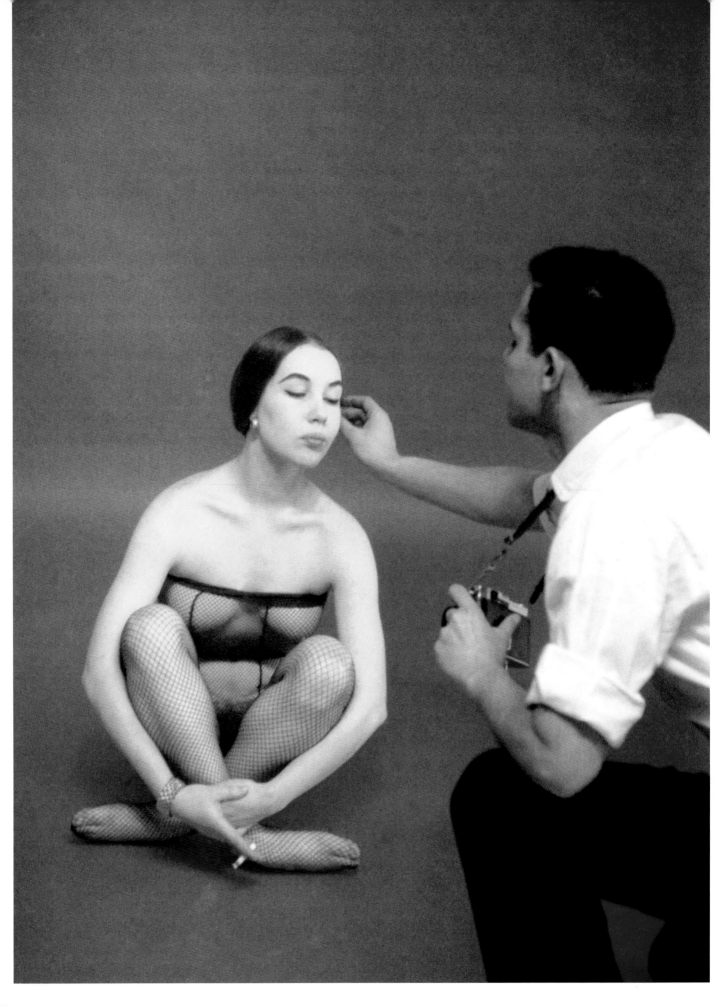

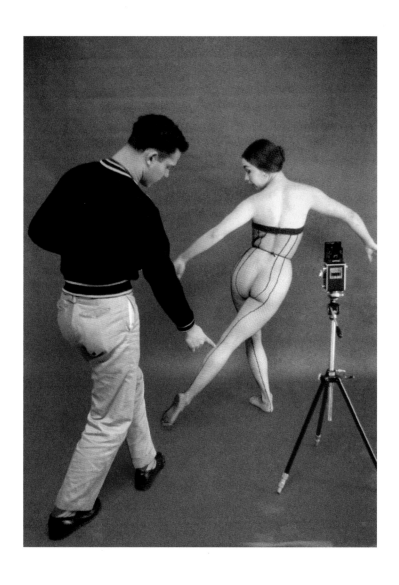

Anita Huffington must model for money.
Here she poses for photographer
Michael Tabb. (Overleaf) Anita is the student
of top dancer Merce Cunningham. Her goal:
"To dance the way I want. That's the main thing, to dance."

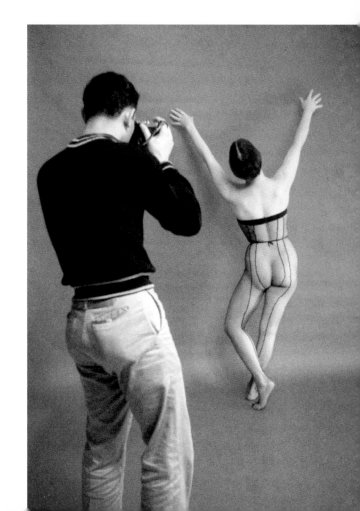

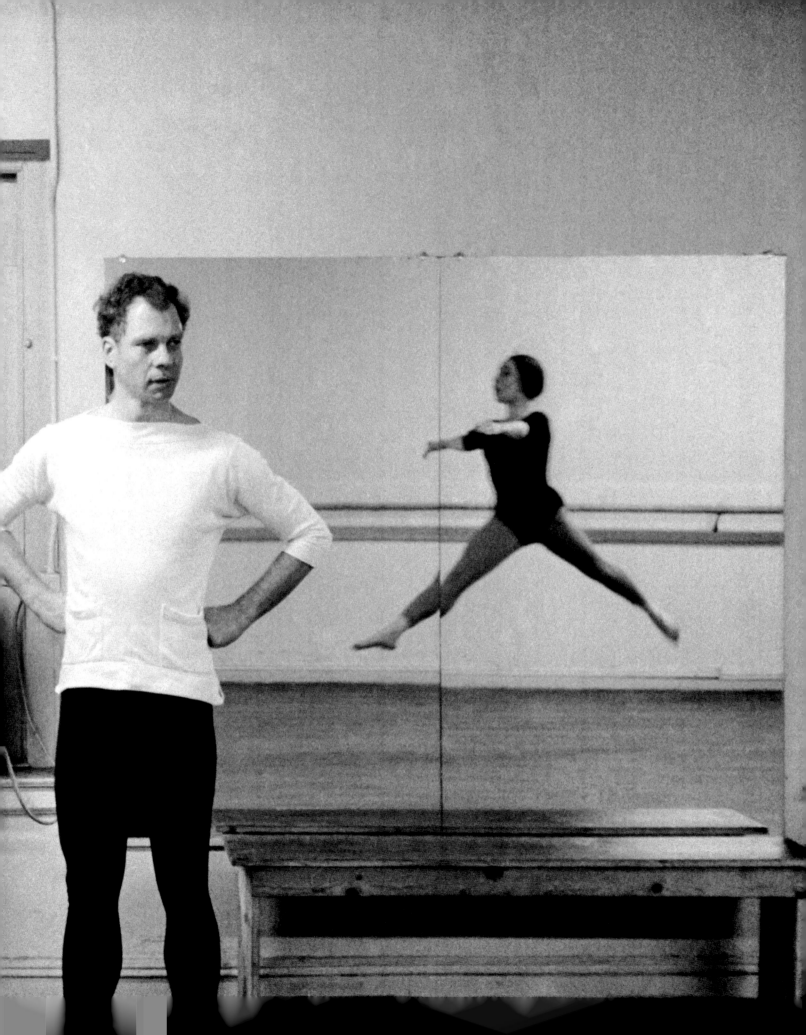

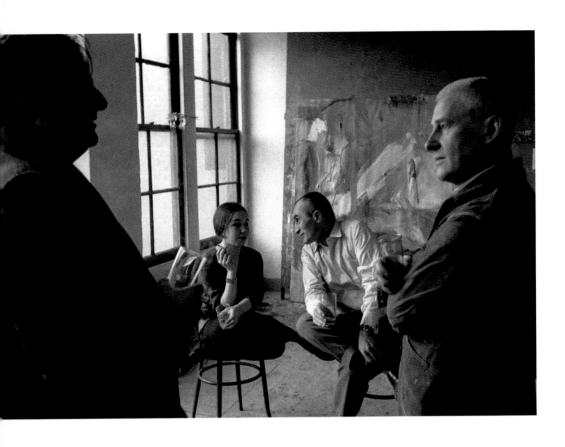

(Top, left to right) Alexander Kaldis, Anita Huffington,
Larry Rivers and Willem de Kooning discuss
art at de Kooning's studio.

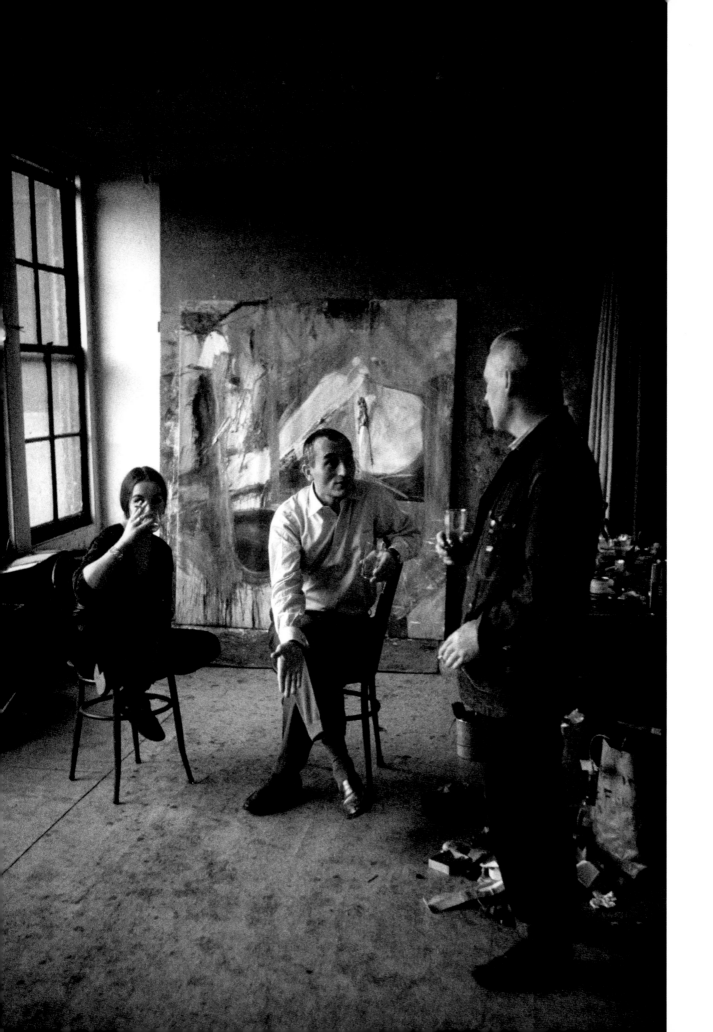

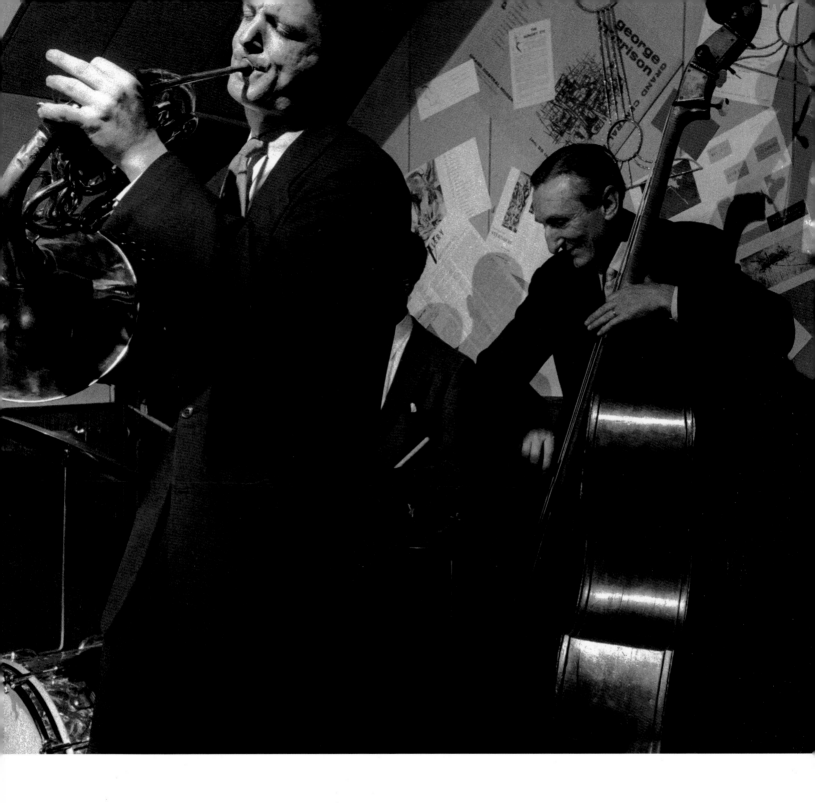

Upper and lower Bohemia meet at new jazz spot.

 (Above) David Amram leads his jazz group with French art dealer Michel
Tapié during an impromptu session. (Opposite) a back table at the Five Spot (left
 to right) are sculptor David Smith, art guru Frank O'Hara,
a poet; Larry Rivers and Grace Hartigan, both artists;
 an economist, Sidney Rolfe; dancer Anita Huffington; and Bill Hunter,
a neurosurgeon. The lady with her back to the camera is painter Helen
Frankenthaler. Peak crowd is about midnight. In quieter moments,
 a poet will sometimes read his verse to the music. Bar jumps till four A.M.

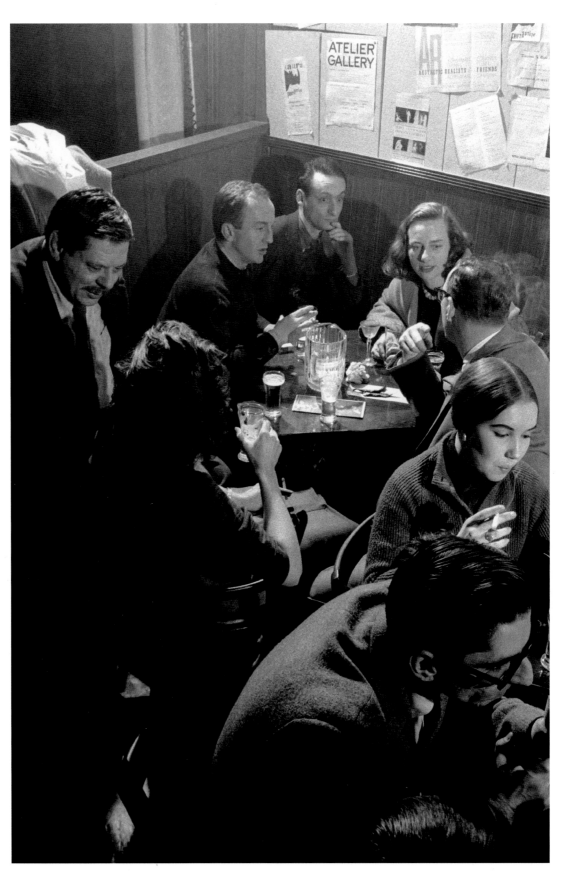

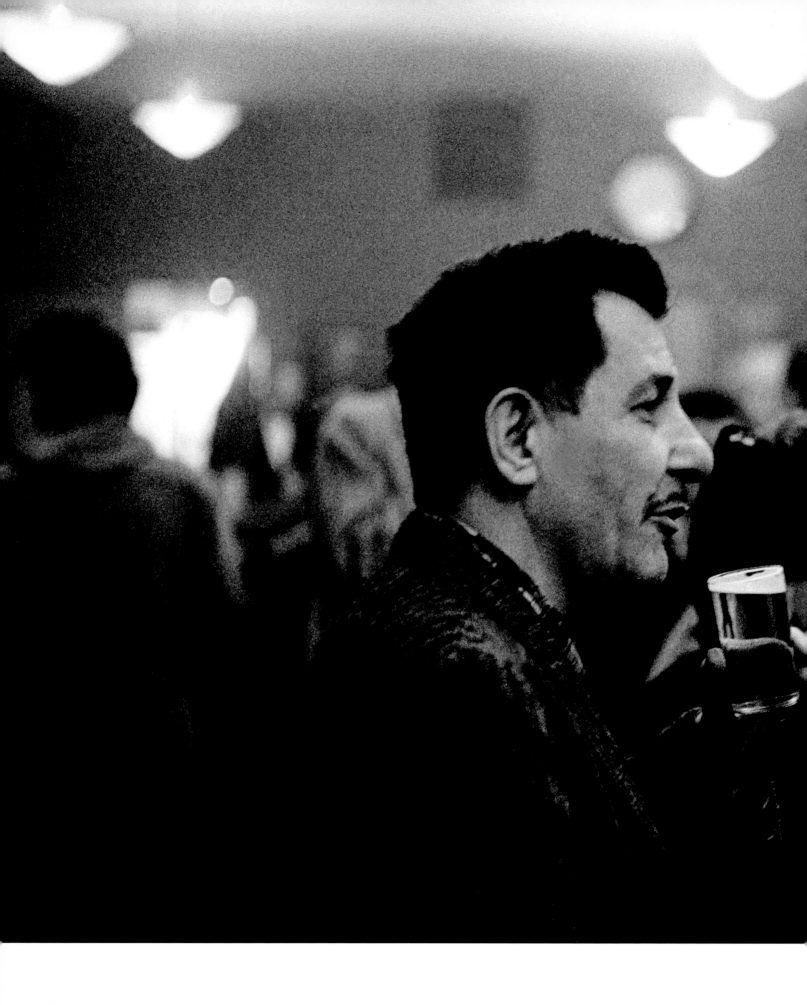

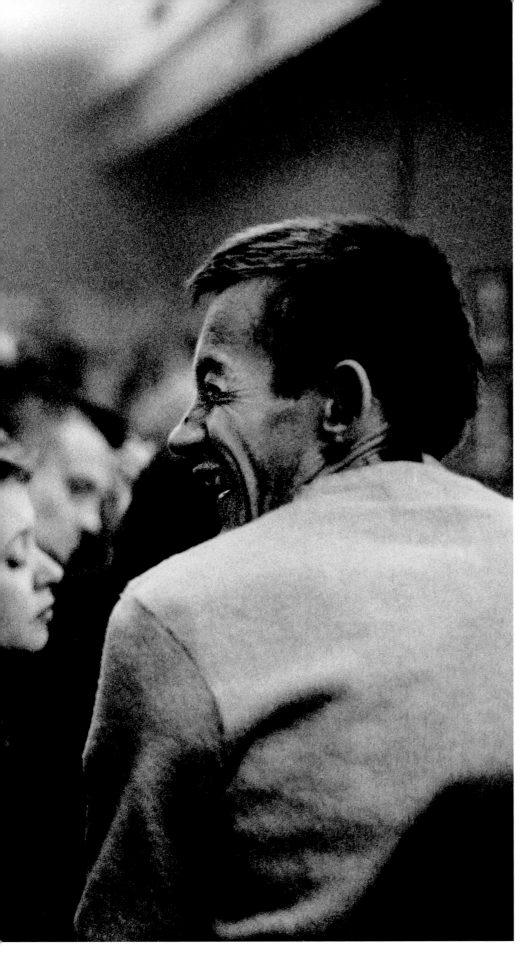

Painter Franz Kline with friend at the Five Spot Café.

Allen Ginsberg and Barney Rosset talk in an art gallery
with Gregory Corso and poet Peter Orlovsky.
(Opposite, from left) Allen Ginsberg, Gregory Corso,
and Barney Rosset, owner of the publishing house Grove Press, in Washington Square Park.

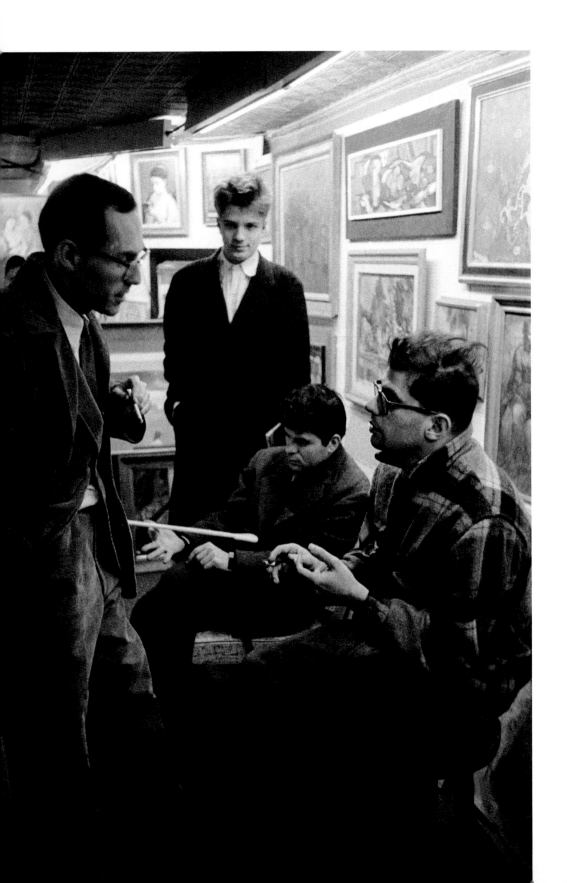

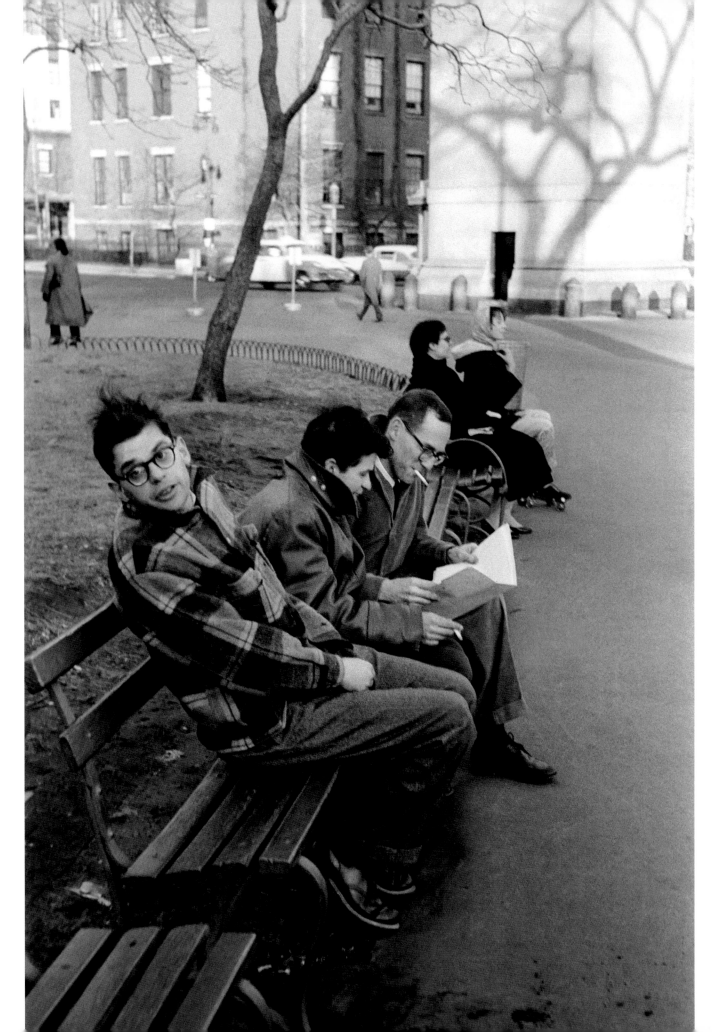

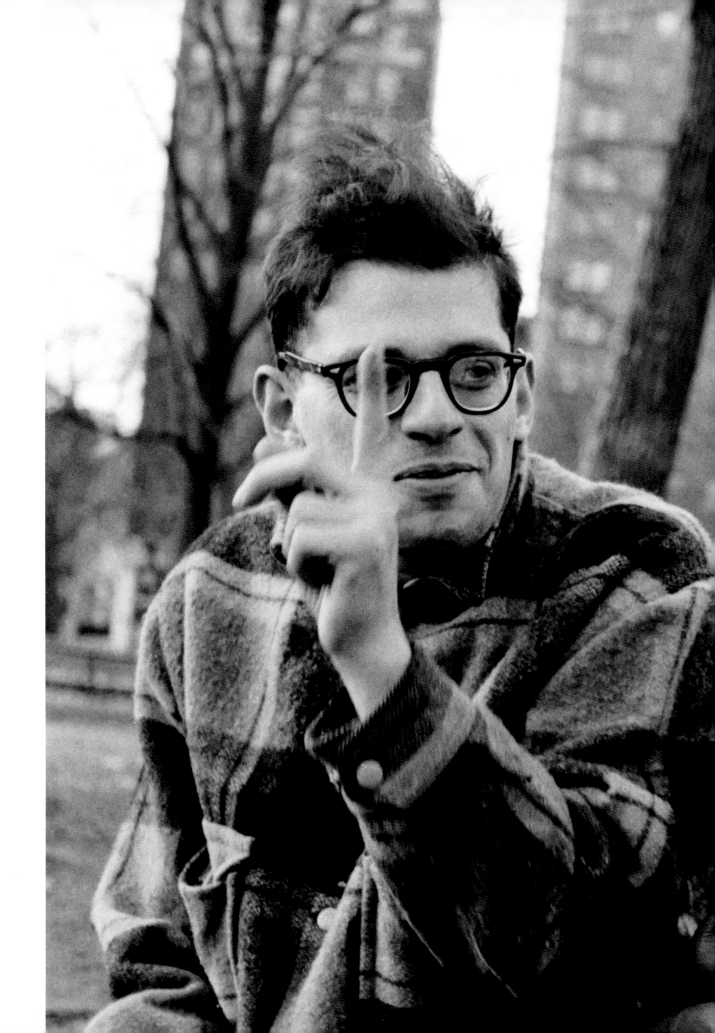

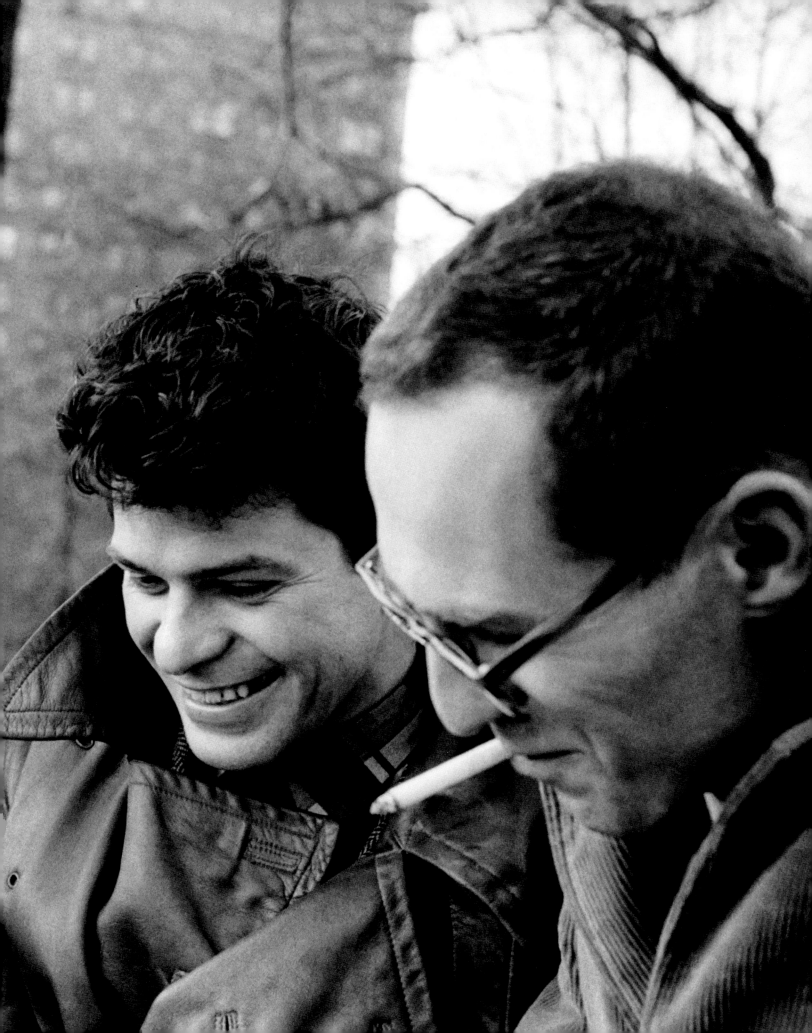

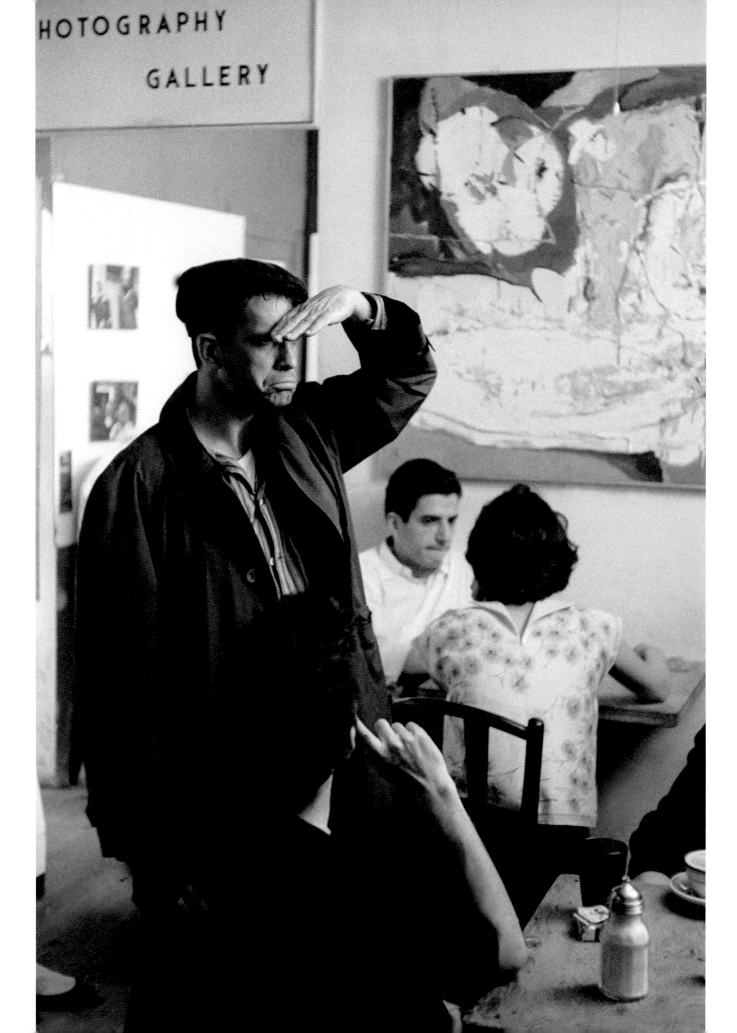

east coast beats 1959

Jack Kerouac at the Seven Arts Coffee Gallery.

Up these stairs, the entrance of the Seven Arts
Coffee Gallery, climb the night-reading
 poets and their public. Poetry is
 read till the early hours of the morning.

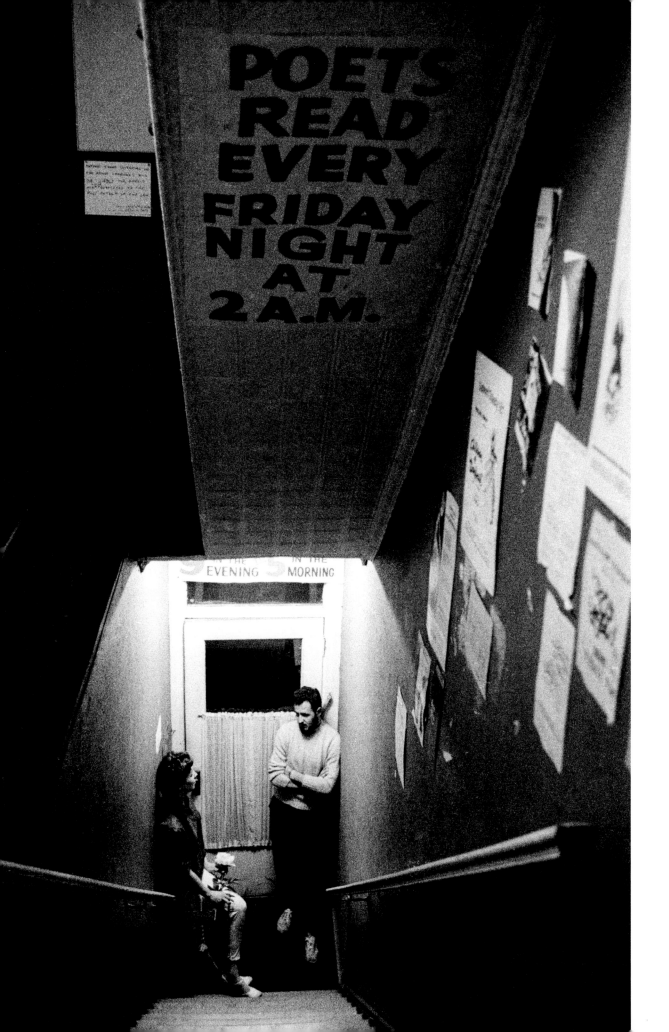

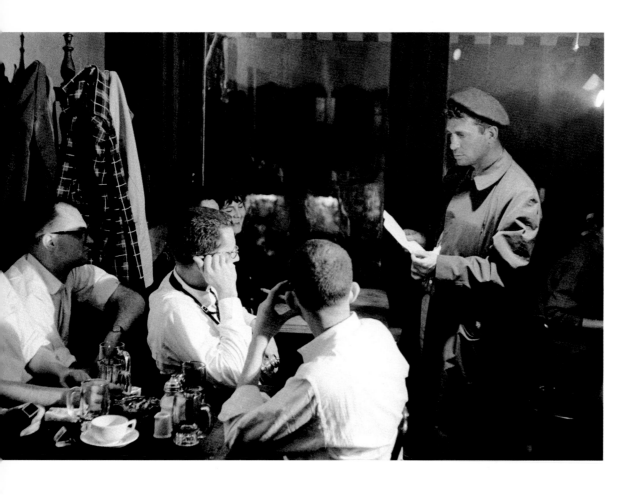

Jack Kerouac holds forth to an enraptured audience.

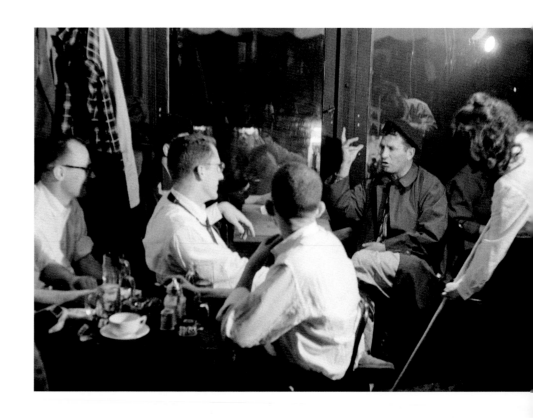

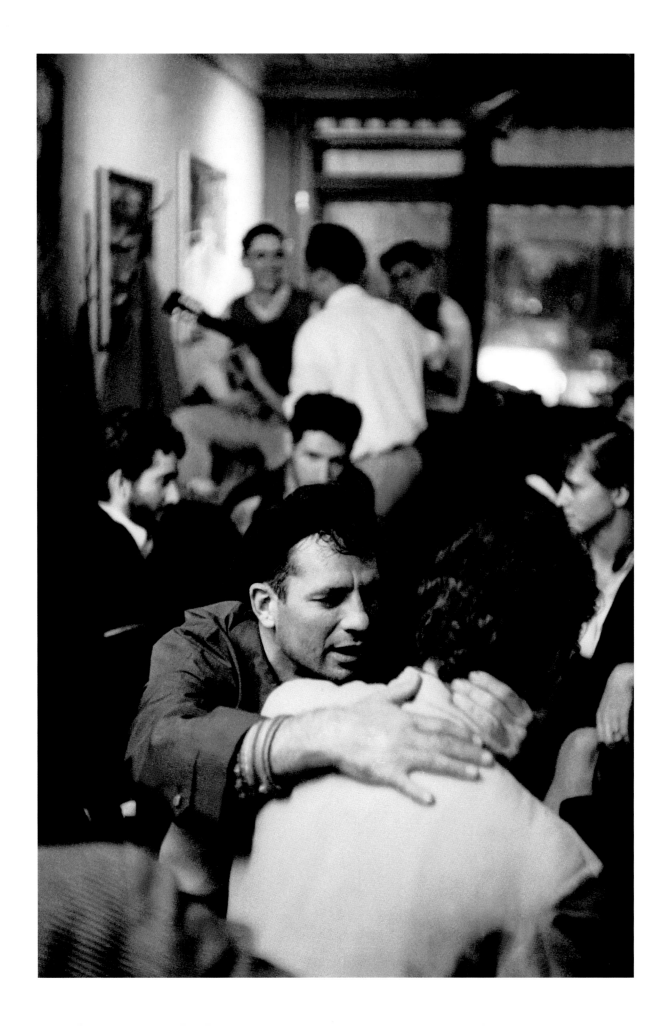

Kerouac, wearing Beatnik uniform—dark glasses
and a beret—speaks with Barbara Ferrara.

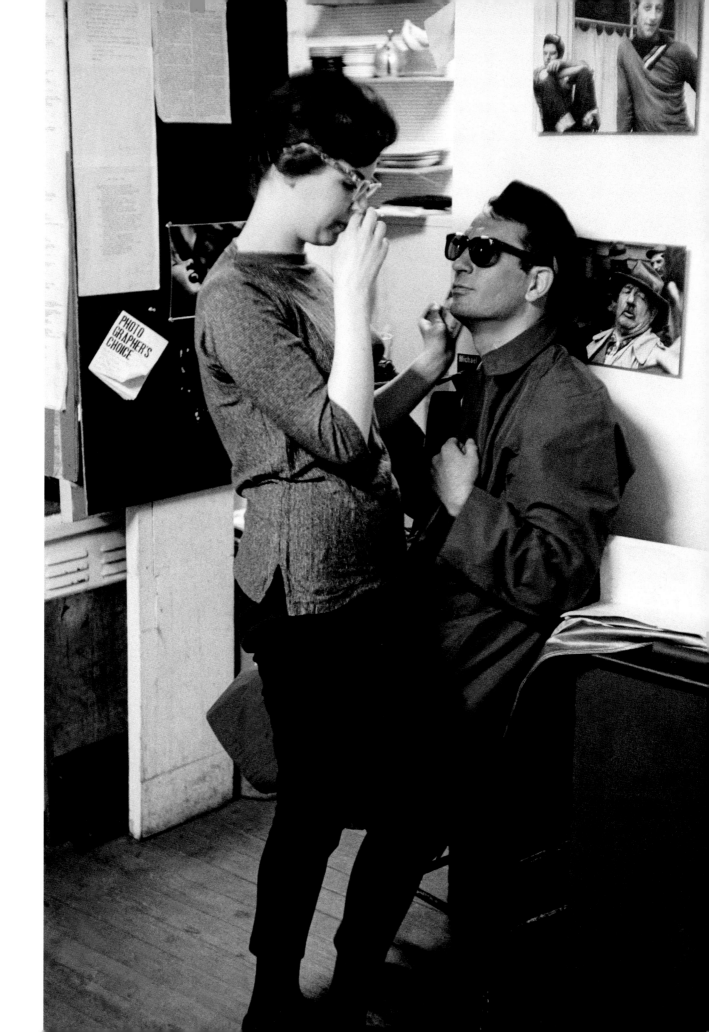

Jack Kerouac talks to John Rapinic,
the owner of the Seven Arts Coffee
Gallery. (Opposite) Gregory Corso begins to
read his poems "Gasoline" and "Bomb".

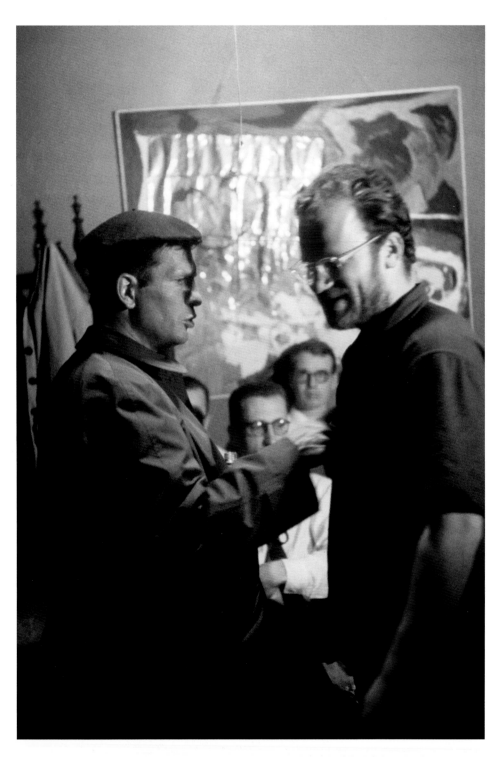

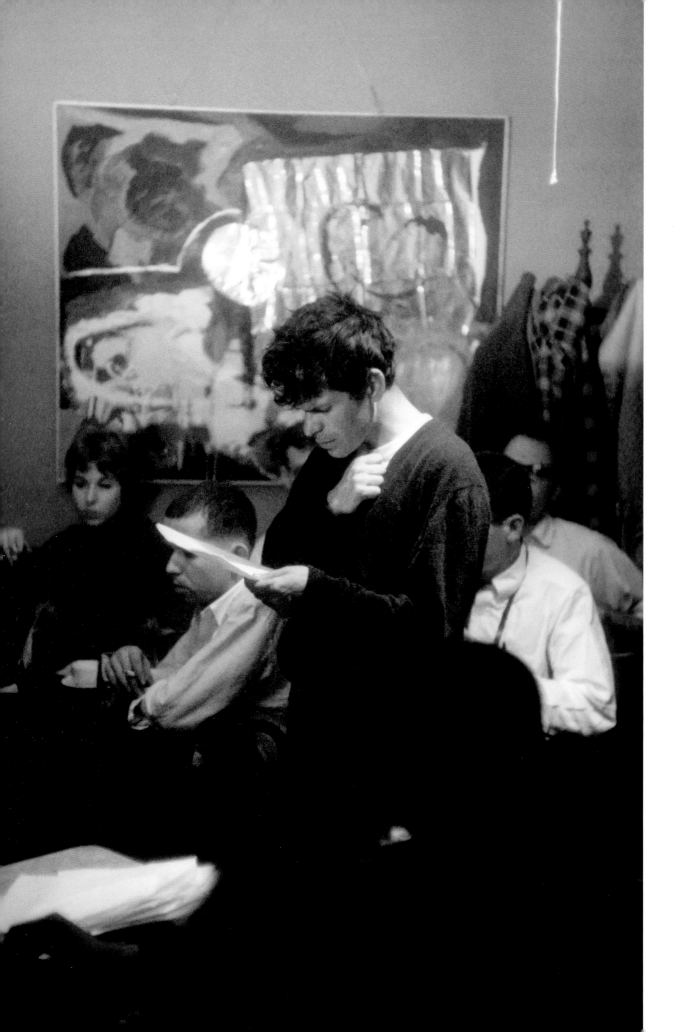

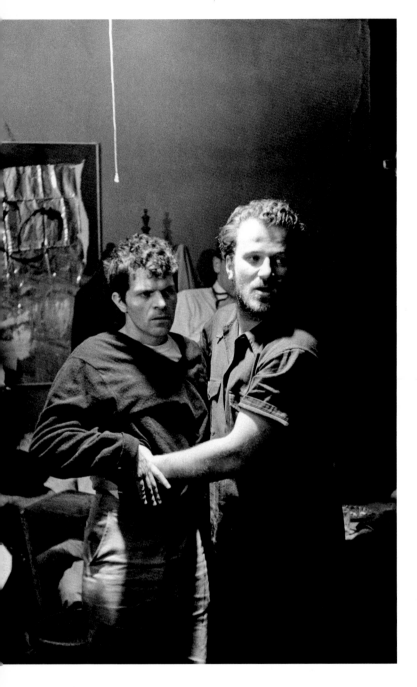
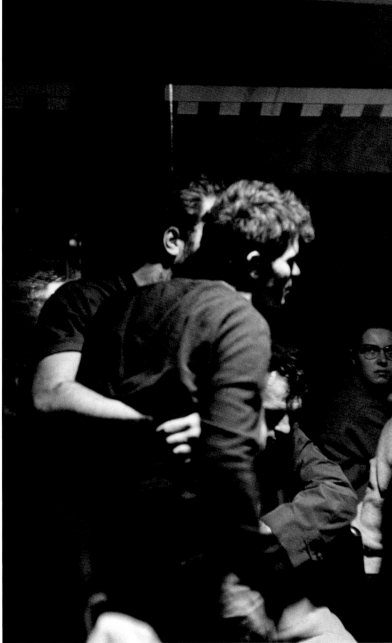

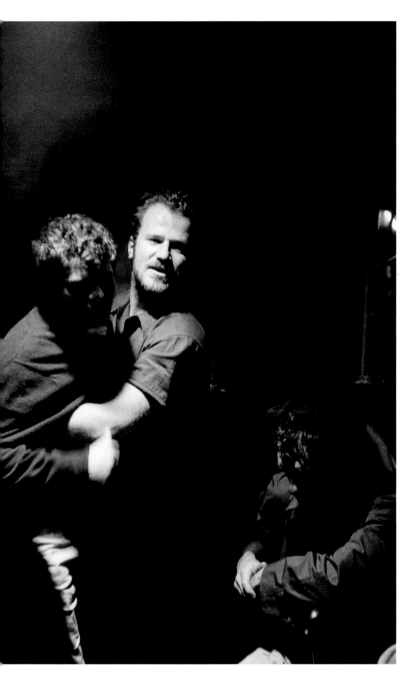
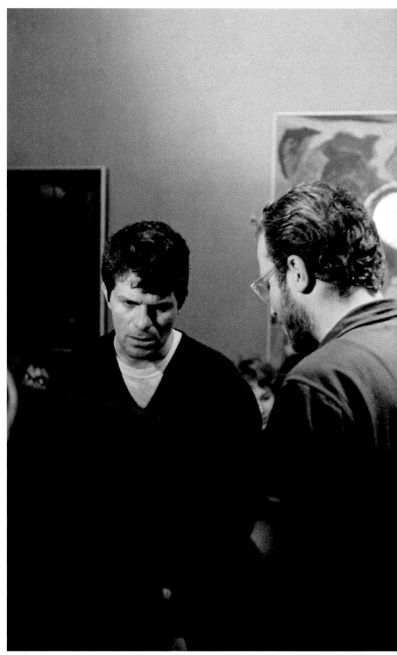

Things get rough. John Rapinic restrains Corso who hurls insults
at reporter: "but you don't understand Kangaroonian weep!
For sake thy trade! Flee to Enchenedian Islands".
In foreground, wizened Kerouac plays it cooler.

After reading, Corso has success with girls
at the Seven Arts Coffee Gallery.
(Opposite) Corso exchanges one sneaker with a Beatnik
admirer. Poetess Barbara Moraff is in the background.

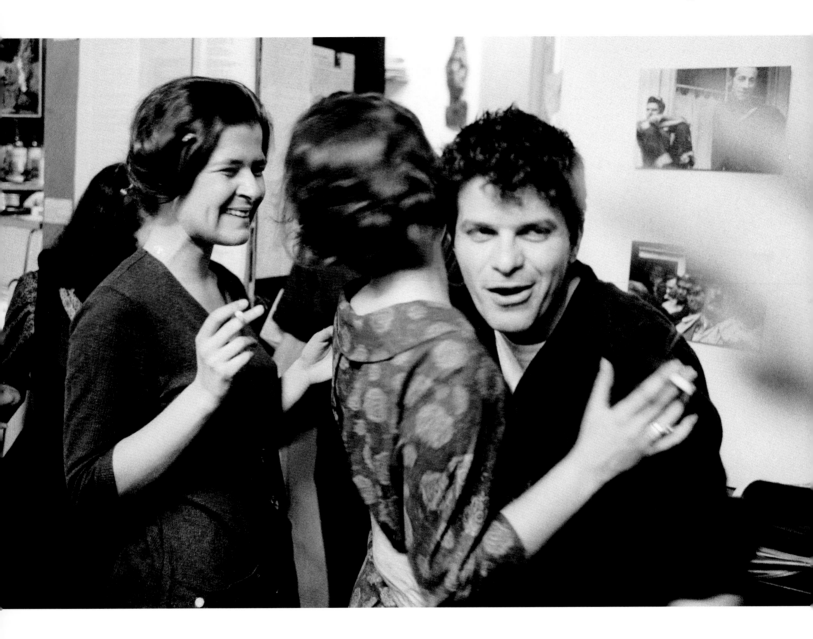

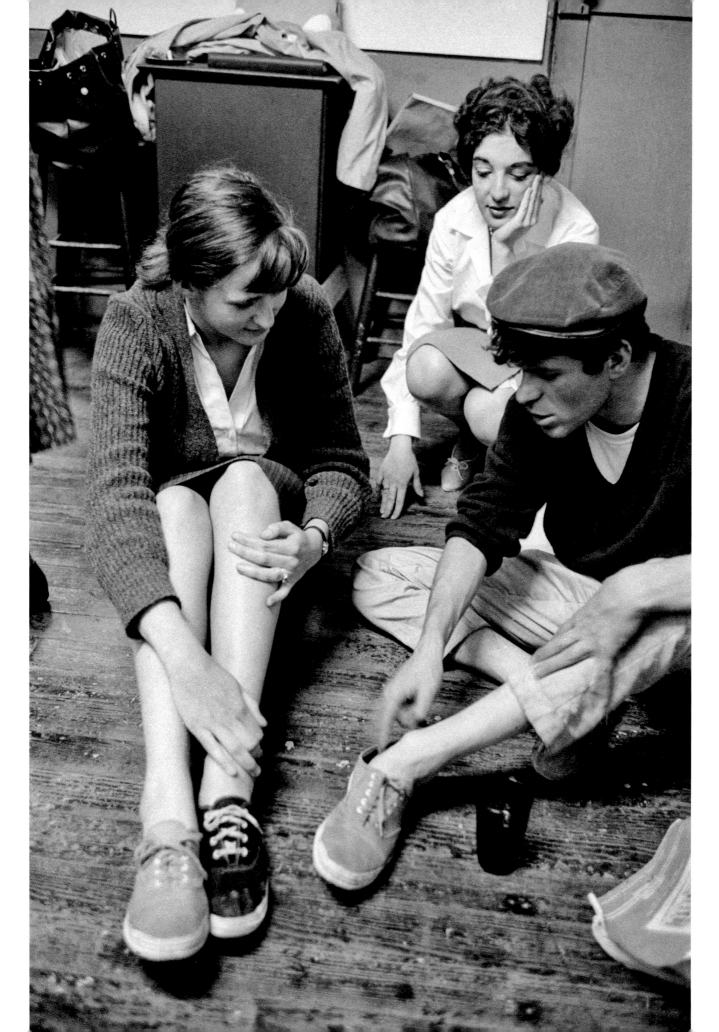

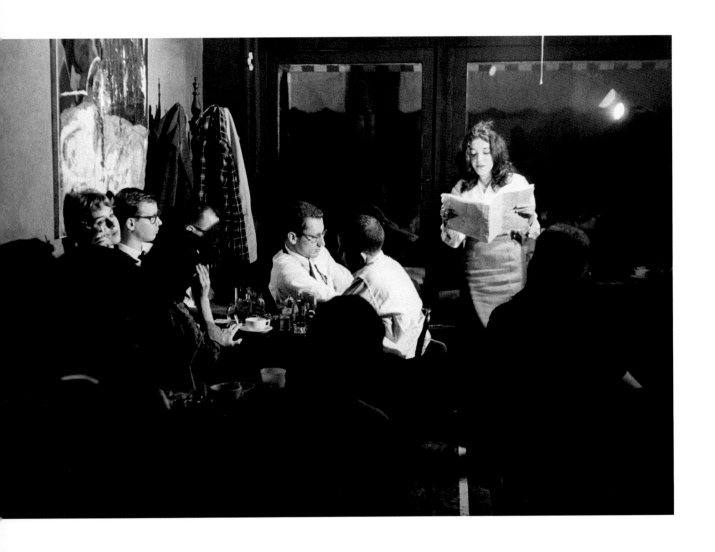

Barbara Moraff reading and serious discussions at Seven Arts Coffee Gallery.

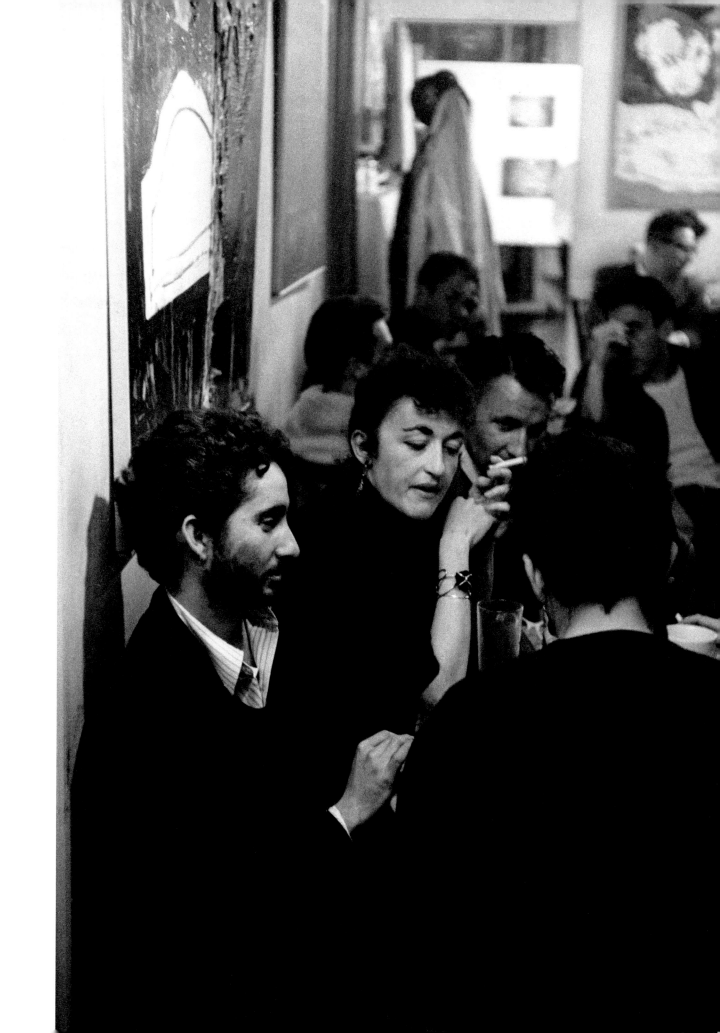

Kerouac at Seven Arts
 with unidentified
disconsolate Beatnik beauty.

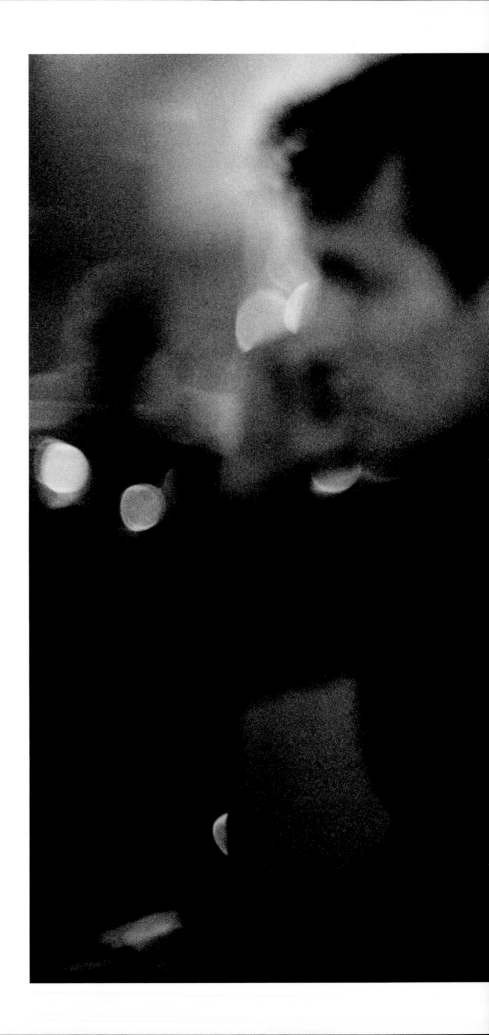

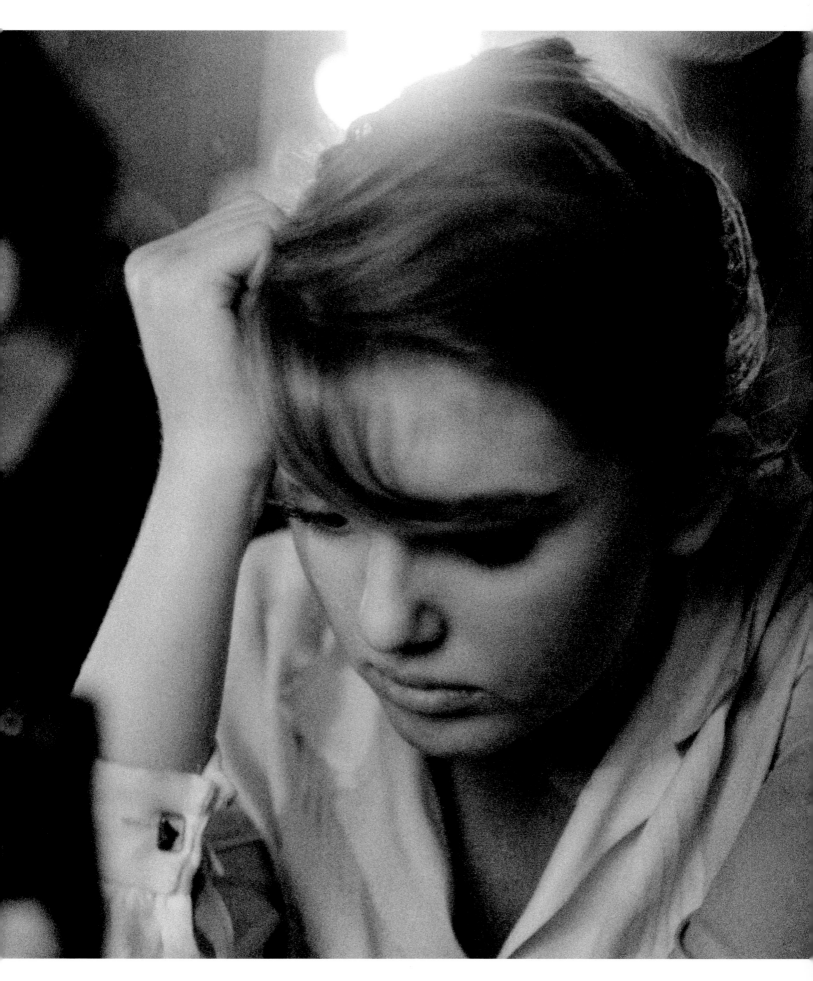

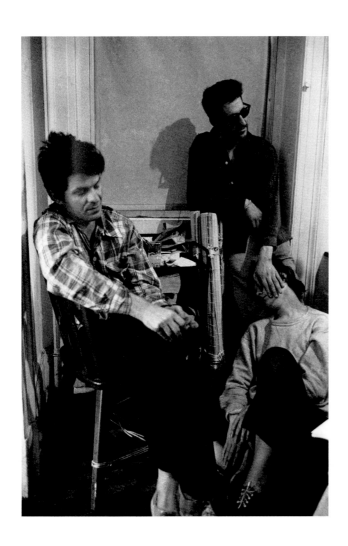

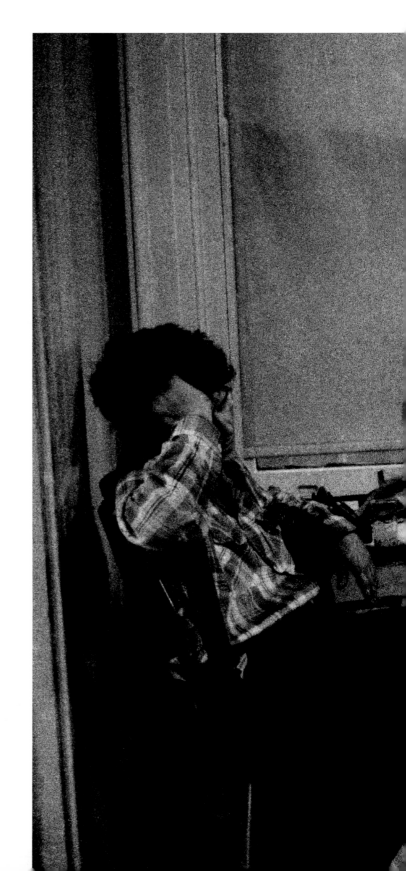

(Left to right) Corso, Ray and Bonnie Bremser,
LeRoi Jones and two unknowns. Party held by
Jones who has just got out a new issue of his
hand-printed Yugen magazine where all his friends' poems appear.

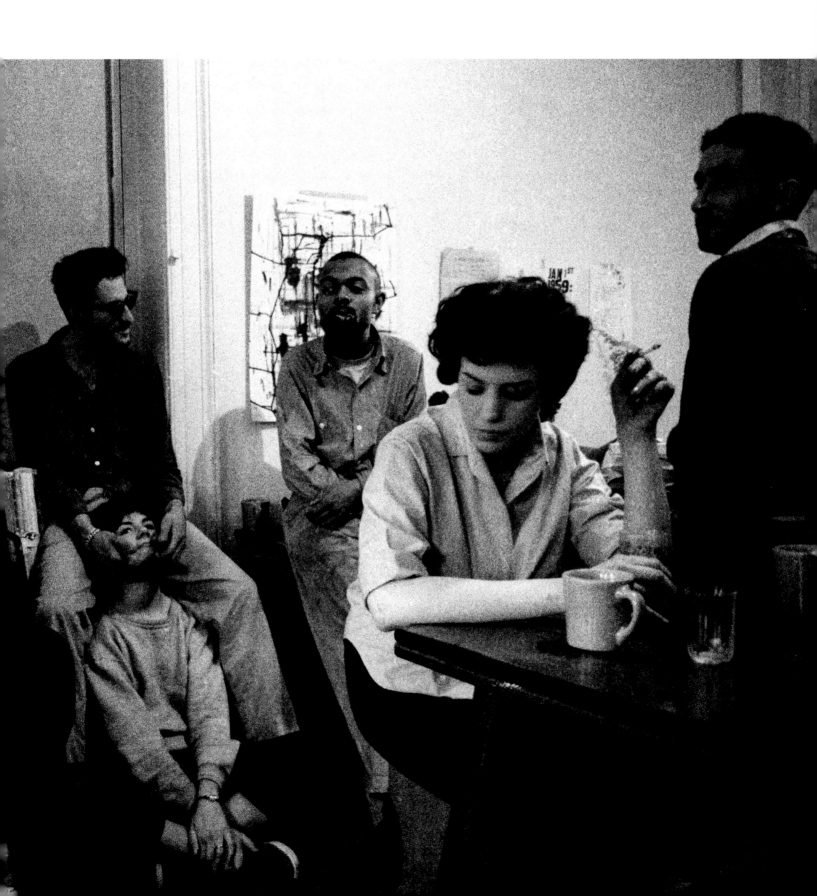

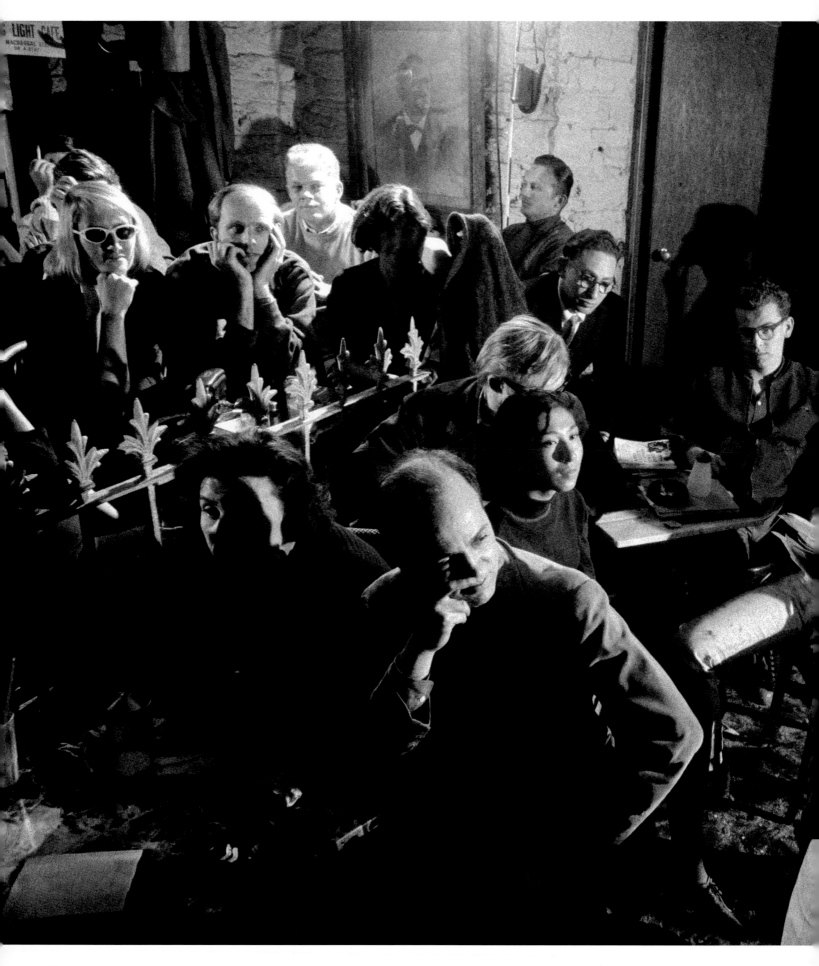

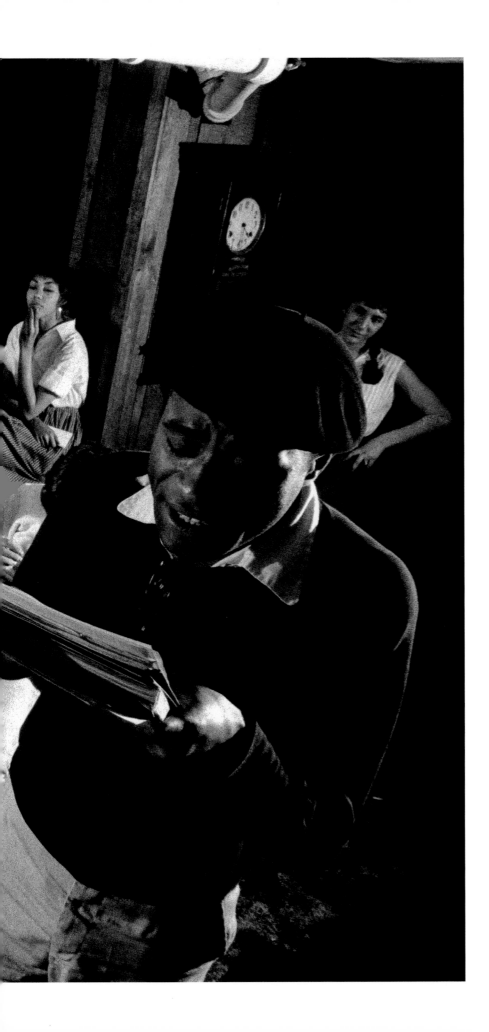

Ted Joans reads his poetry at
 the Bizarre, a coffee shop in
the Village. Joans
 is the only Beat with a sense
of humor about the Beats.

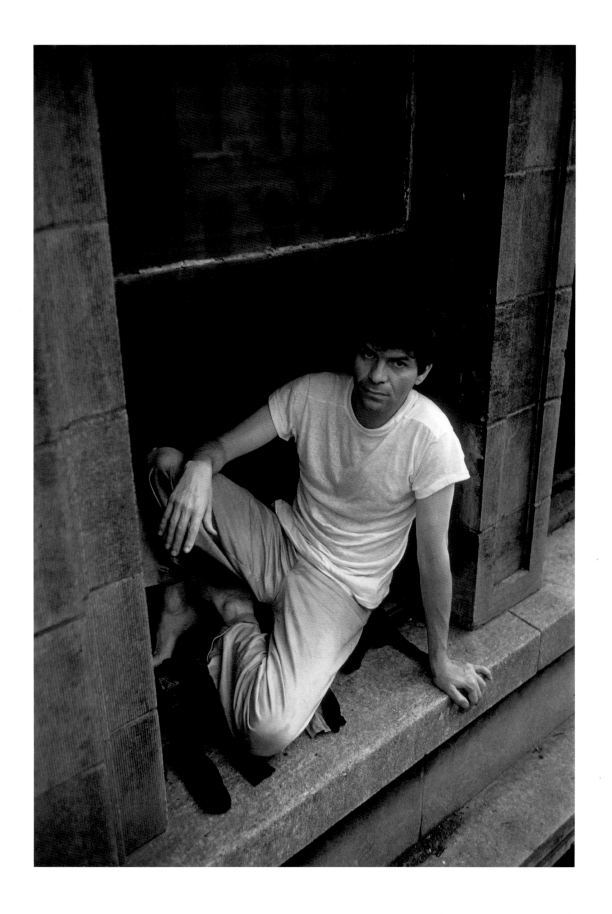

Gregory Corso sits in the window of
Allen Ginsberg's East Village apartment
where he is staying.

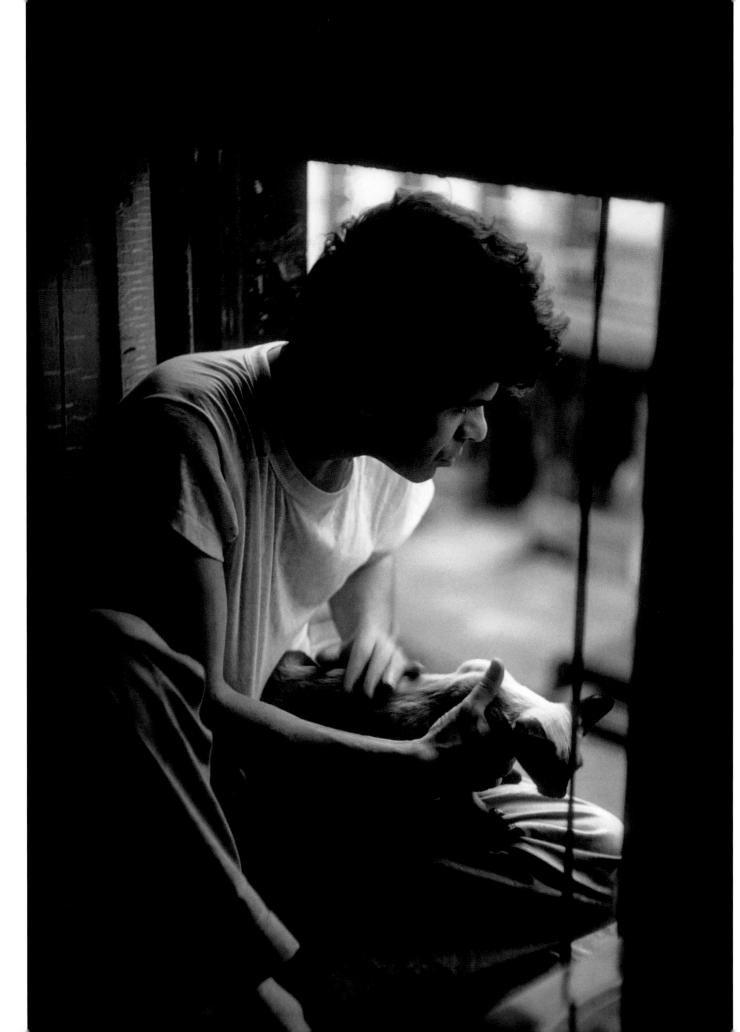

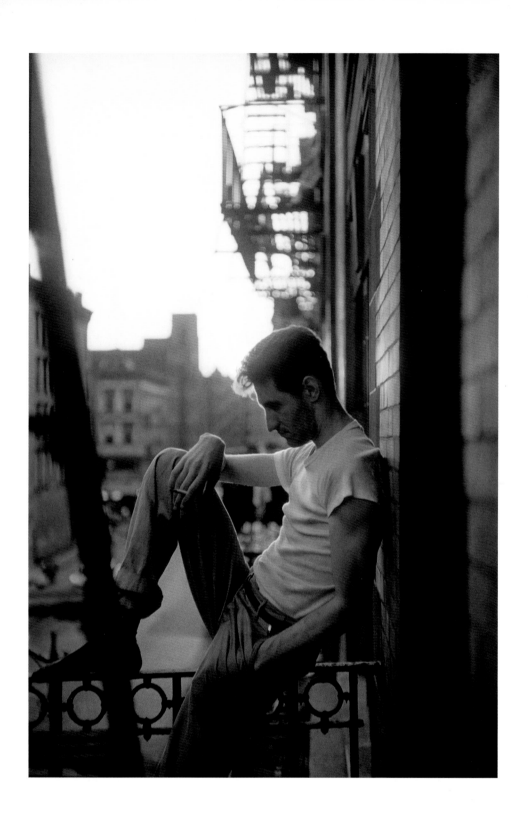

Ray Bremser on the fire escape of Allen Ginsberg's apartment
in the East Village. Bremser is a Beatnik jazz poet
and probably describes himself as an ex-convict.
(Opposite) Mimi Margaux on the balcony of an East Village Beat hangout.
She describes herself as a dancer, actress, model and
follower of "la Vie Boheme."

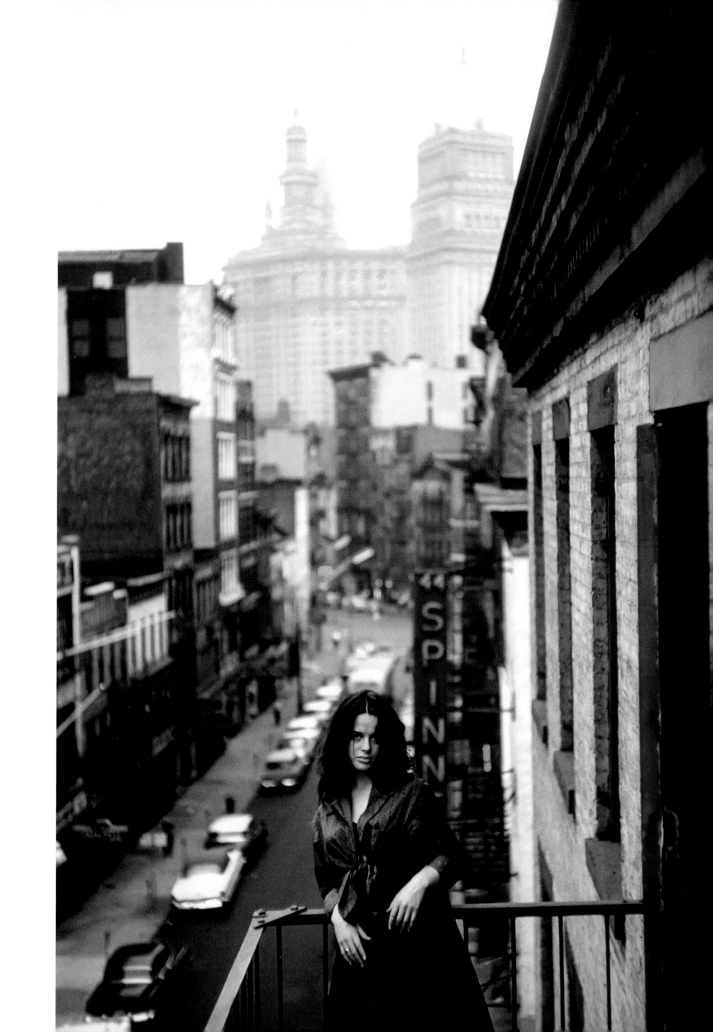

Ray Bremser with his girlfriend,
 Brenda "Bonnie" Frazer, at Allen
Ginsberg's apartment. Ray inherited the
 apartment from Gregory Corso,
 who has just left for Greece
on a tramp streamer with seven dollars,
 an extra pair of socks, a
 tee shirt and a book.

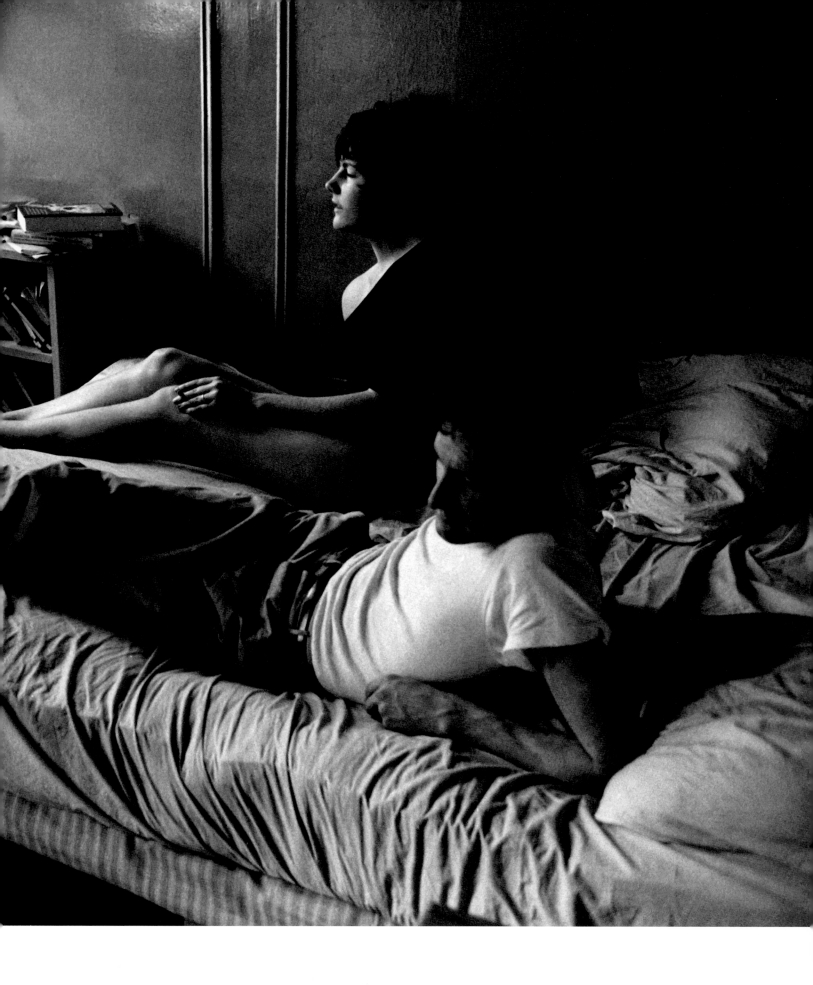

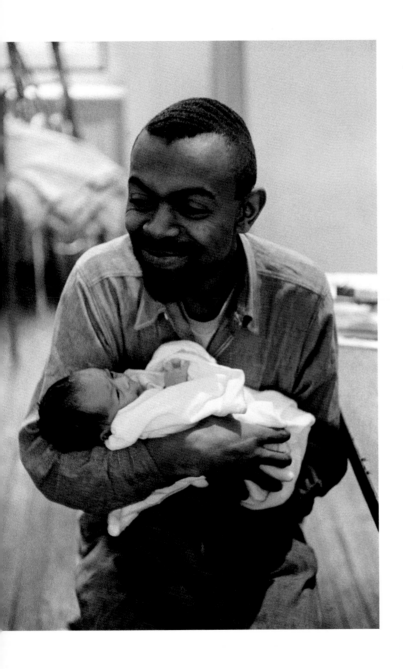

Beat writer LeRoi Jones
with his newborn child.

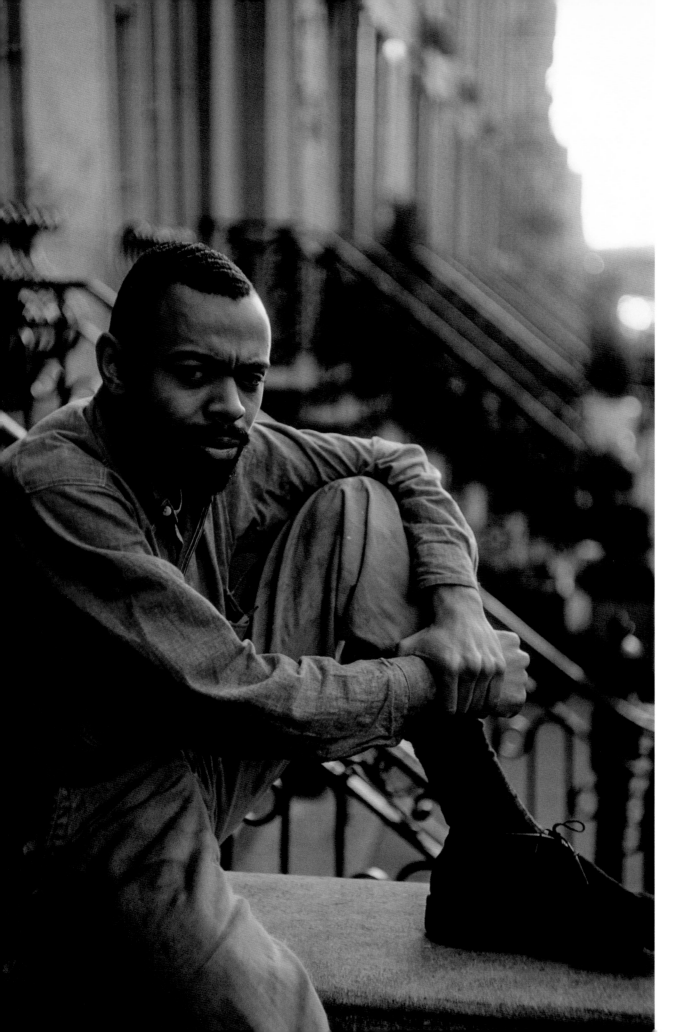

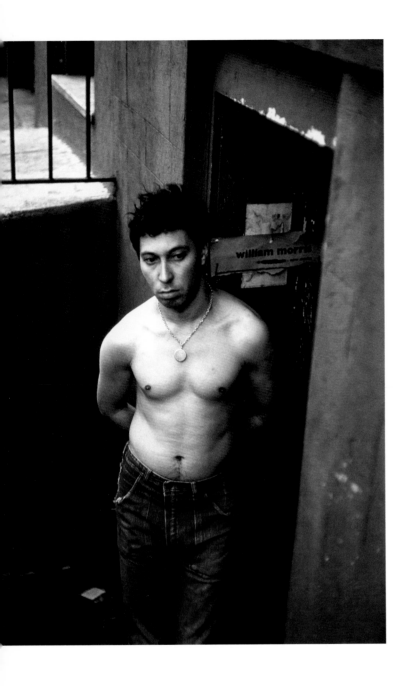

Young William Morris in the doorway of his
 studio apartment at 212 Sullivan Street. William is one of the more
commercial of the Beats. He is a painter? Poet? And quondam guest on
 Jack Paar's show! He is also, in my opinion, definitely Kook.
 (Opposite) William reads poetry at the White Horse Tavern. A somewhat
 historical event as this was the first reading there since
 Dylan Thomas, the Welsh Edgar Guest, read or ranted in the same hall.

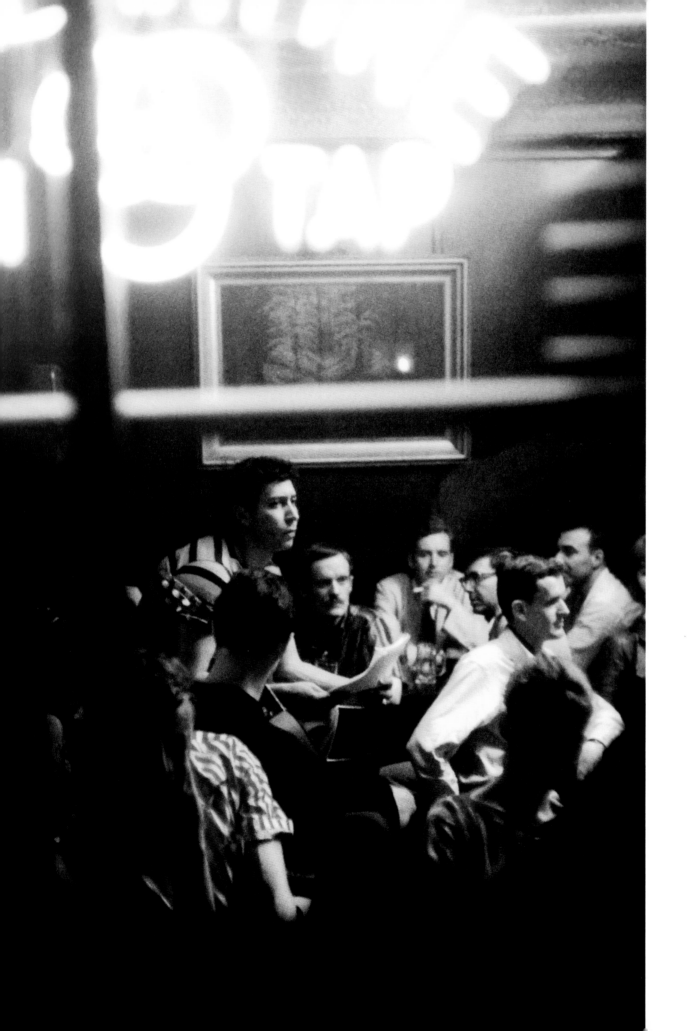

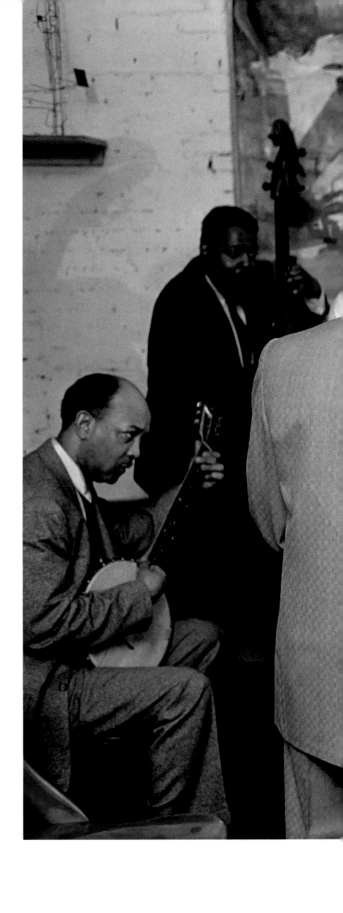

Artist Maurice Bugeaud is celebrating the winning of a Fulbright
Scholarship for study in Europe by hosting a "Rent a Beatnik"
party at his loft on Chrystie and Division streets.

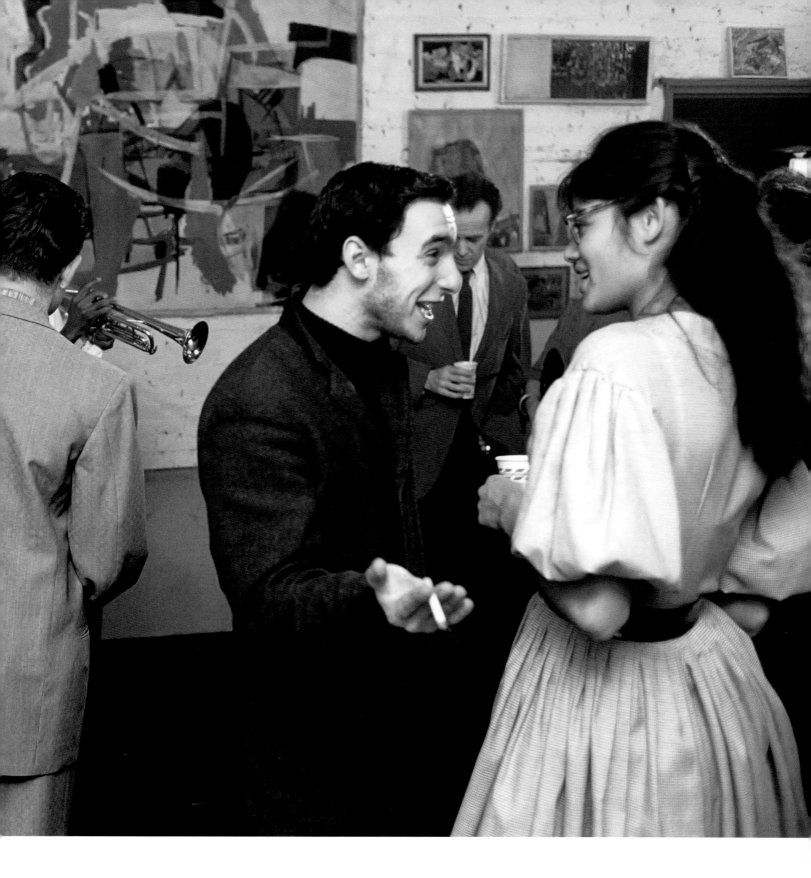

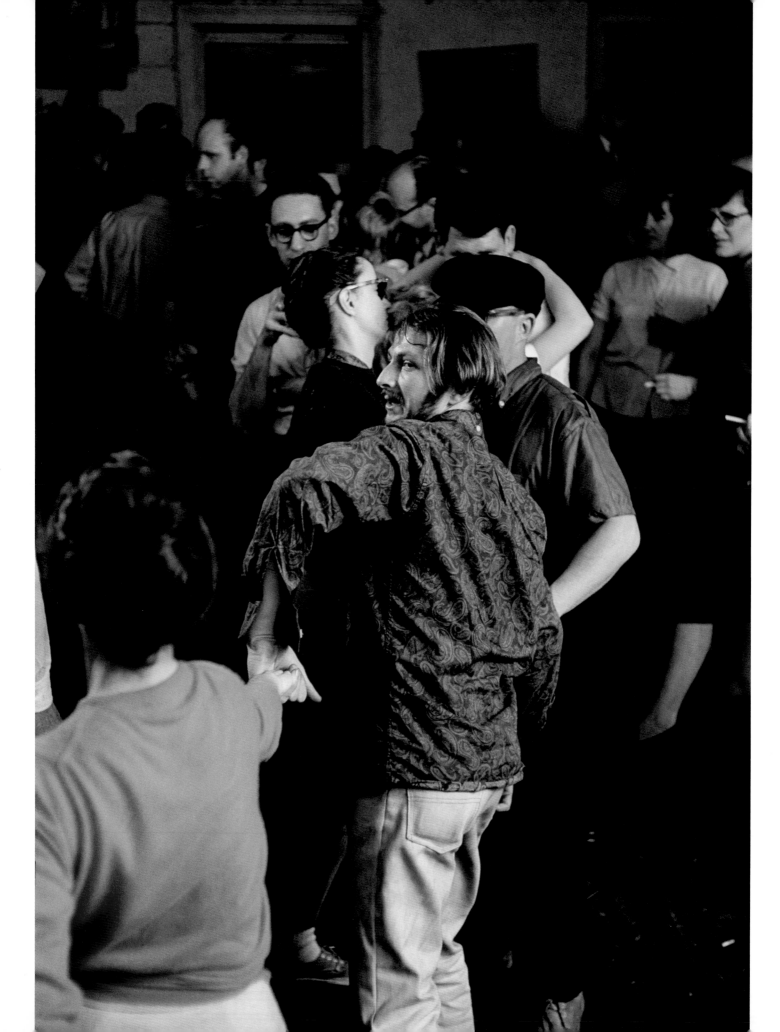

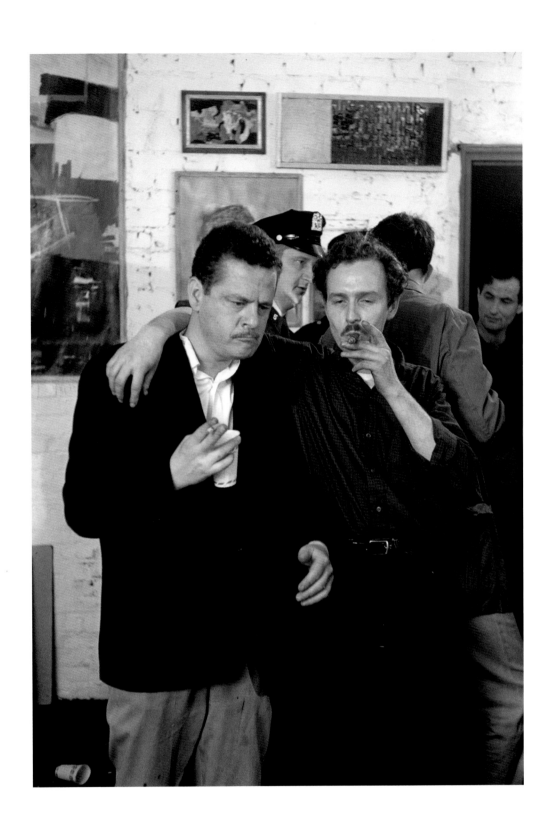

(Opposite) Arty Levin, co-owner of the Seven Arts Coffee Gallery, dances
with Barbara Moraff. Action, fast and unorganized, is part of any acceptable
Beat Generation outing. (Overleaf) The band features Danny Barker on banjo, Kenny Davern
on clarinet, Ahmed Abdul-Malik on bass, Walter Bowe (leader) on
trumpet, and Ephie Resnick on trombone.

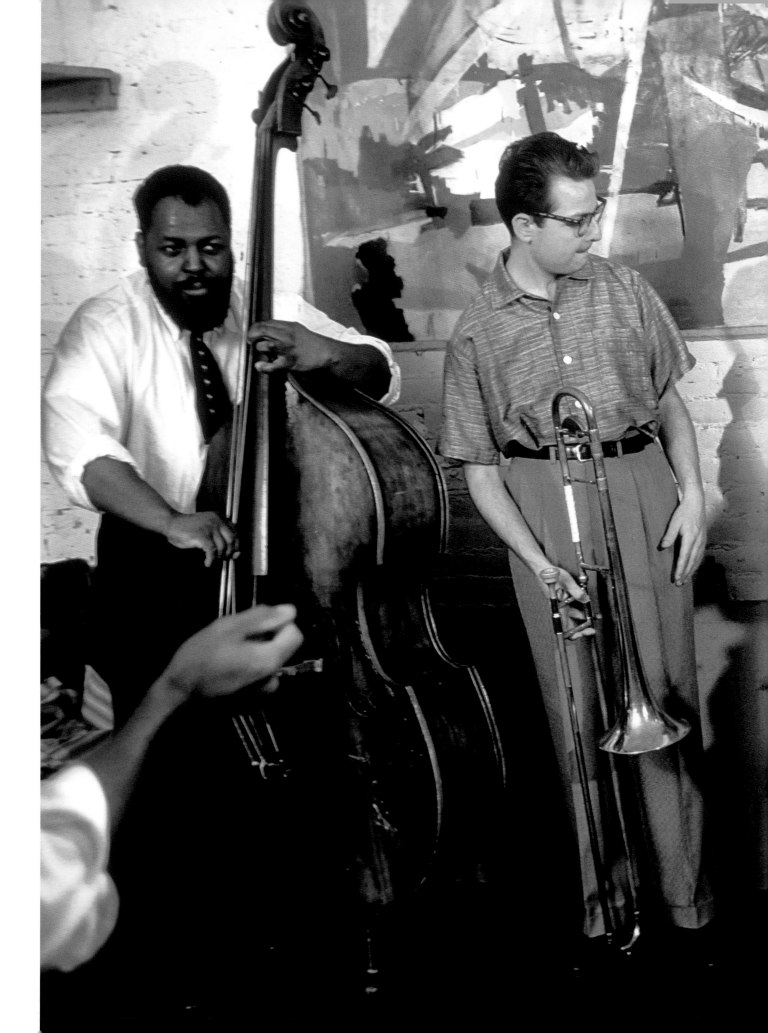

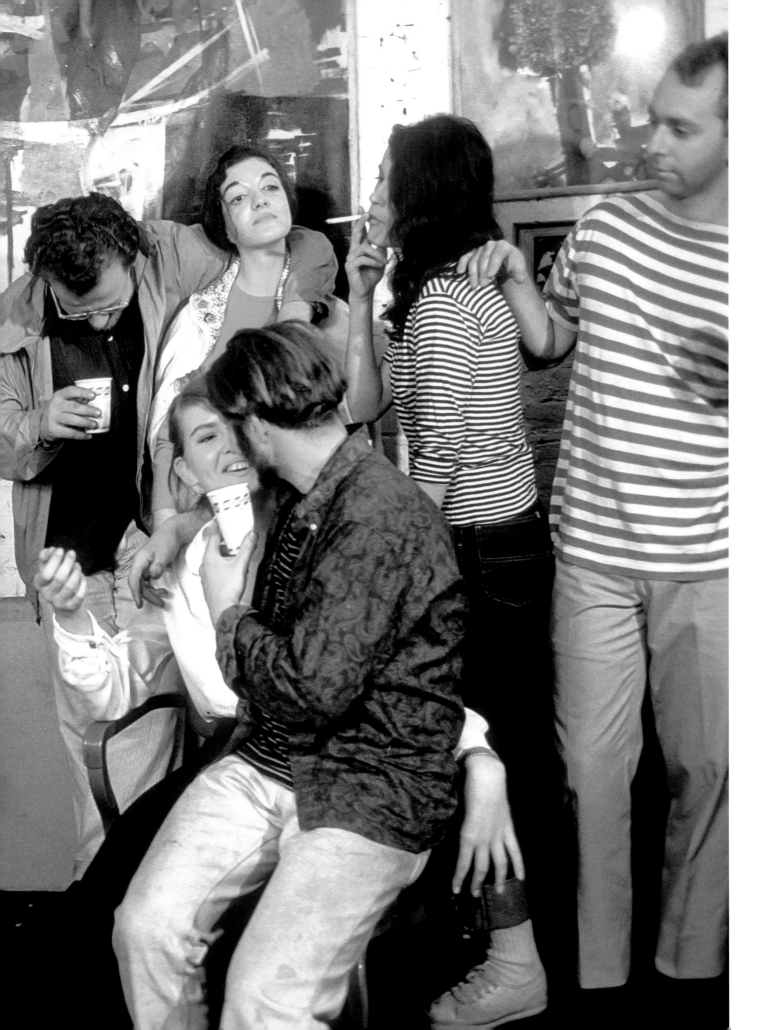

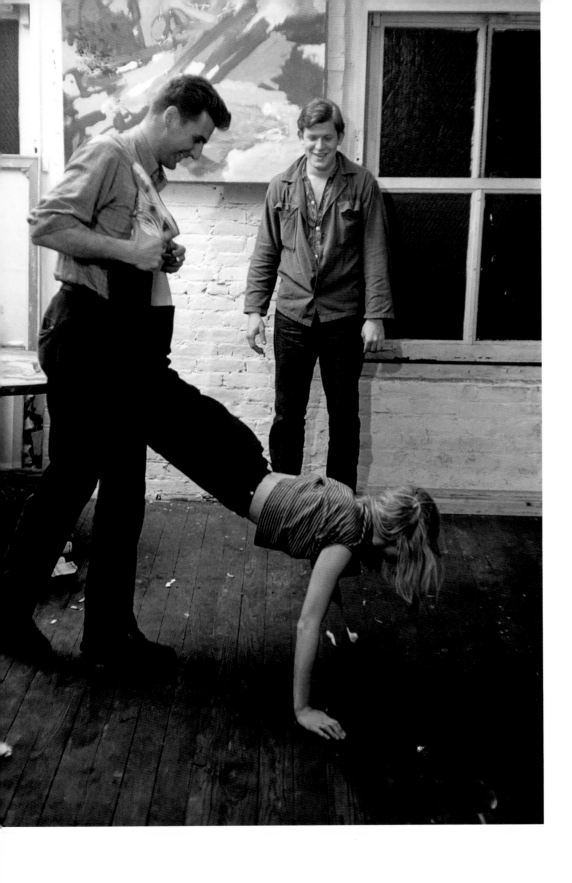

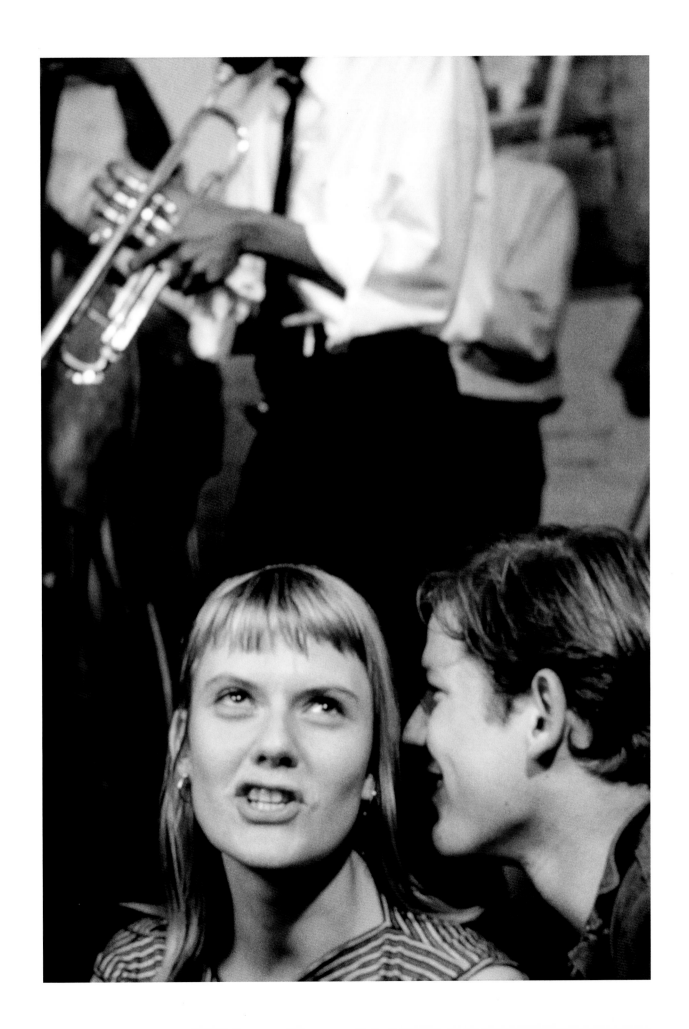

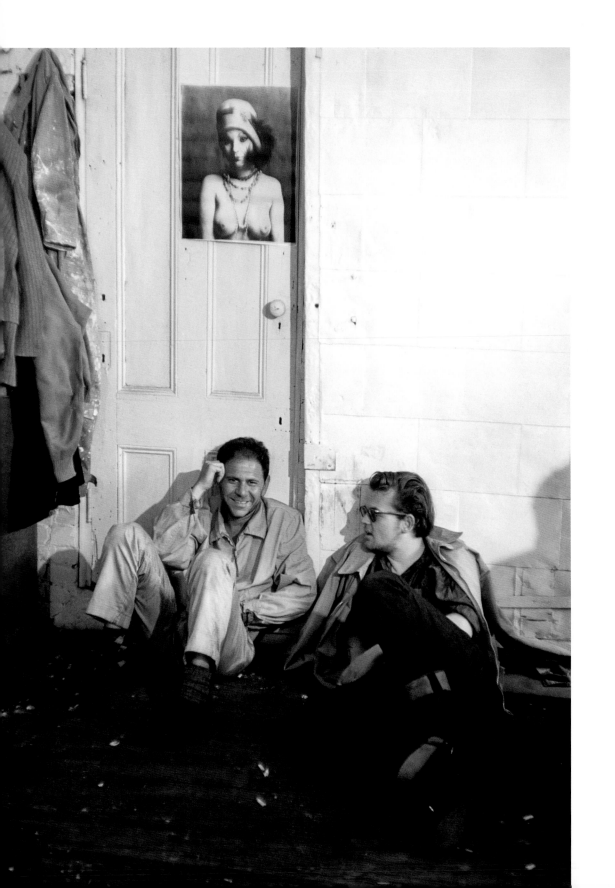

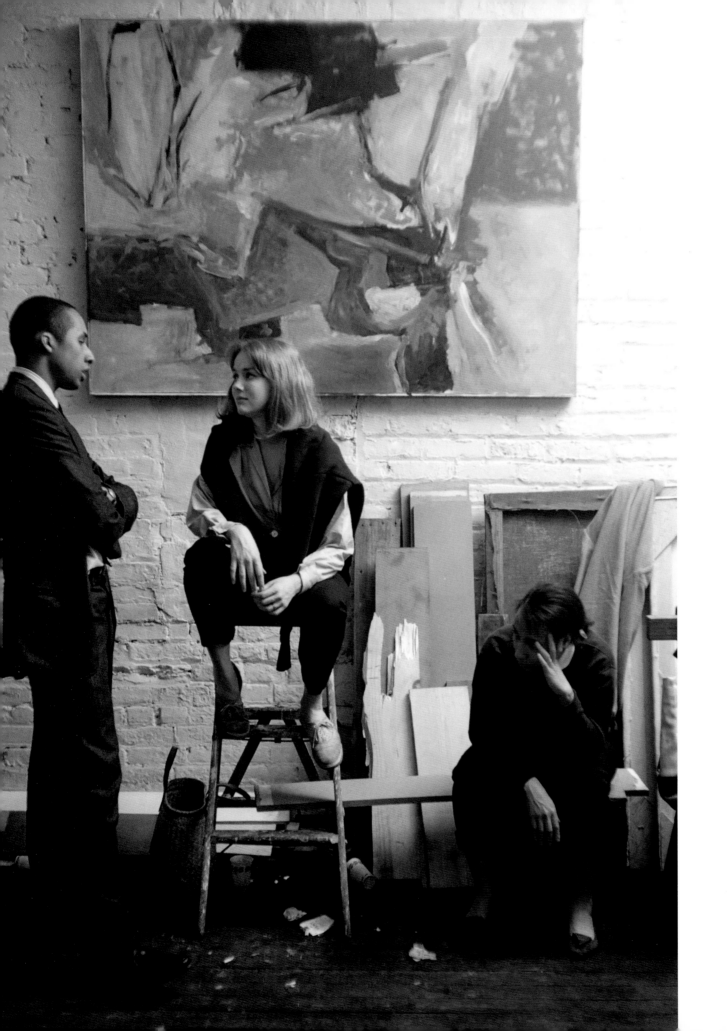

Hugh Romney and a friend at current favourite
hot spot the Half Note, where the jazz band play on
top of the liquor cabinet. The soul of this kind
of New York nightlife is jazz.

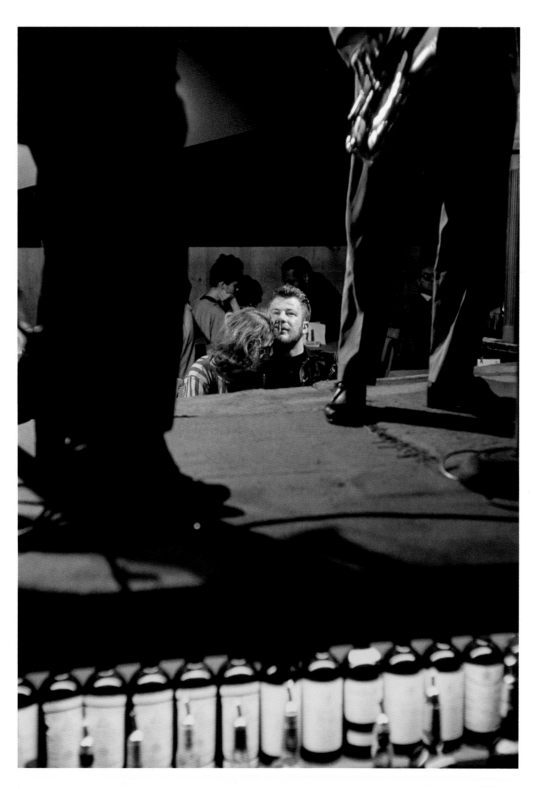

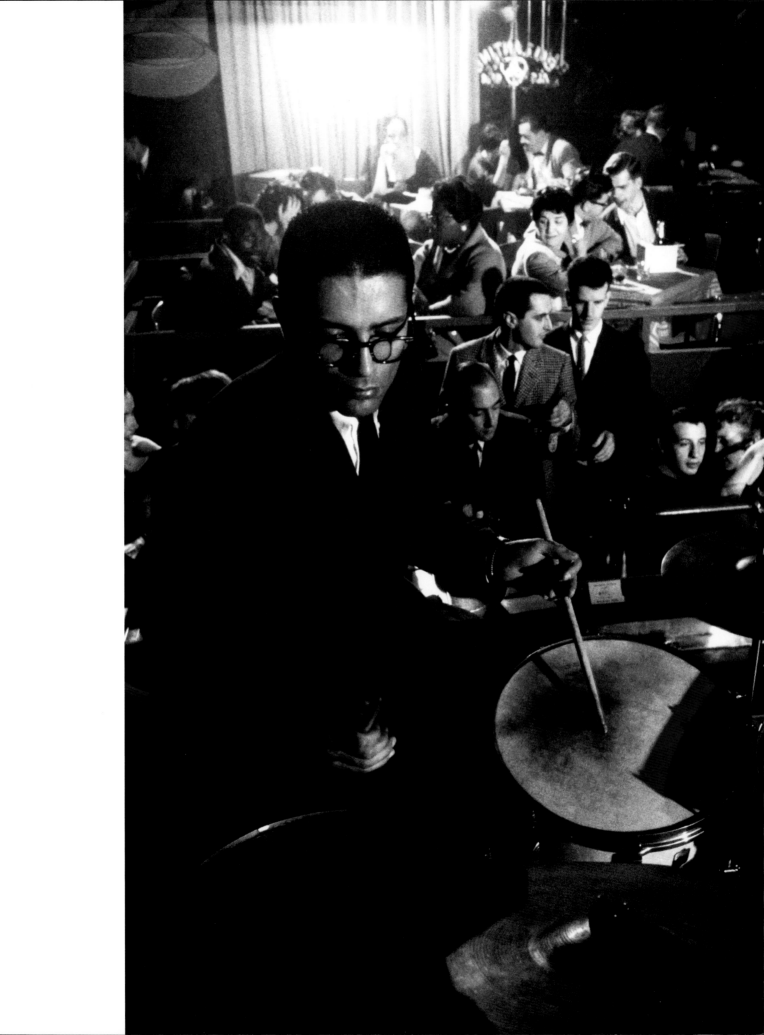

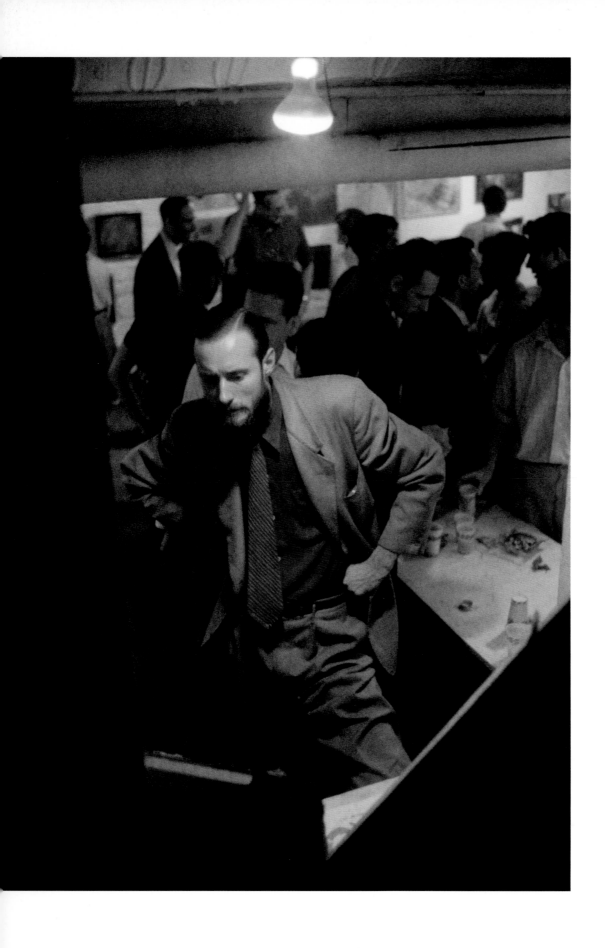

Opening of the March Gallery, and the bearded one gazing
at the work of art is Bob Tiemann, a painter.

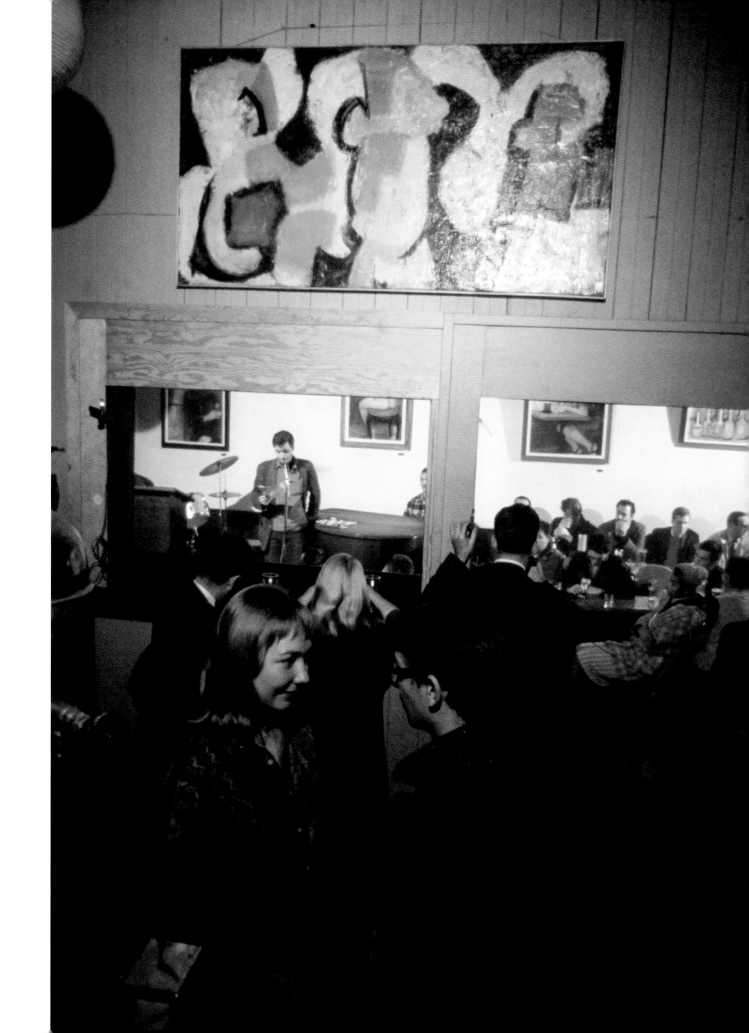

Participating artists in the
Phoenix Gallery on 3rd Avenue.
They are hanging one of their own shows.

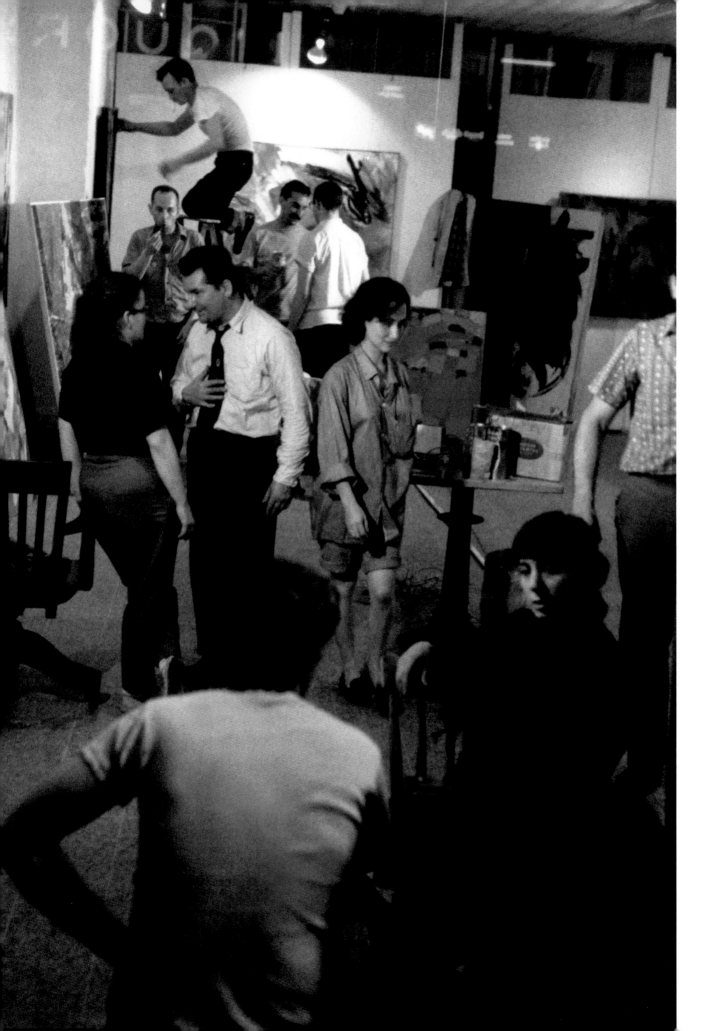

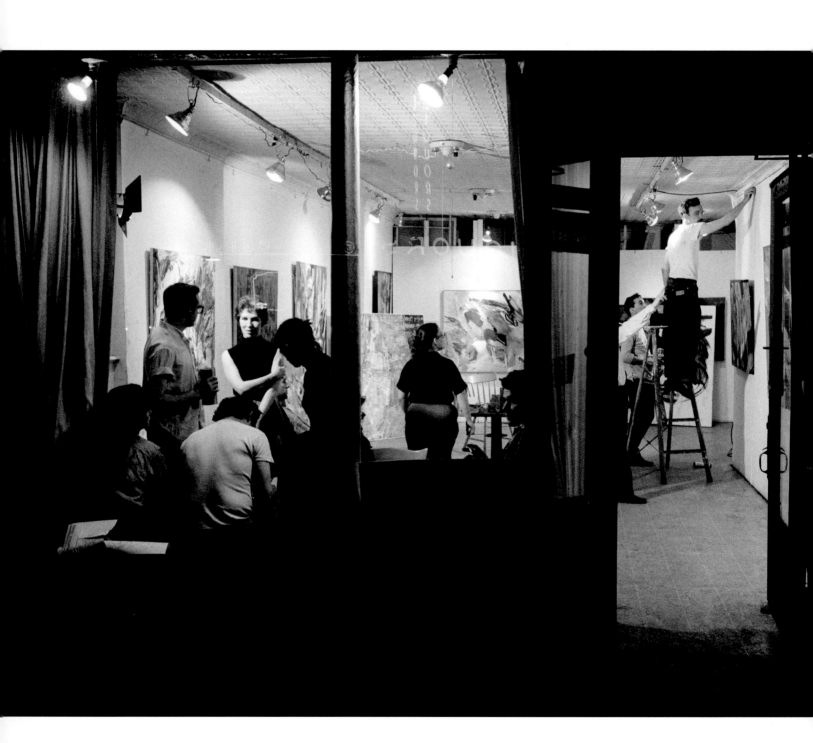

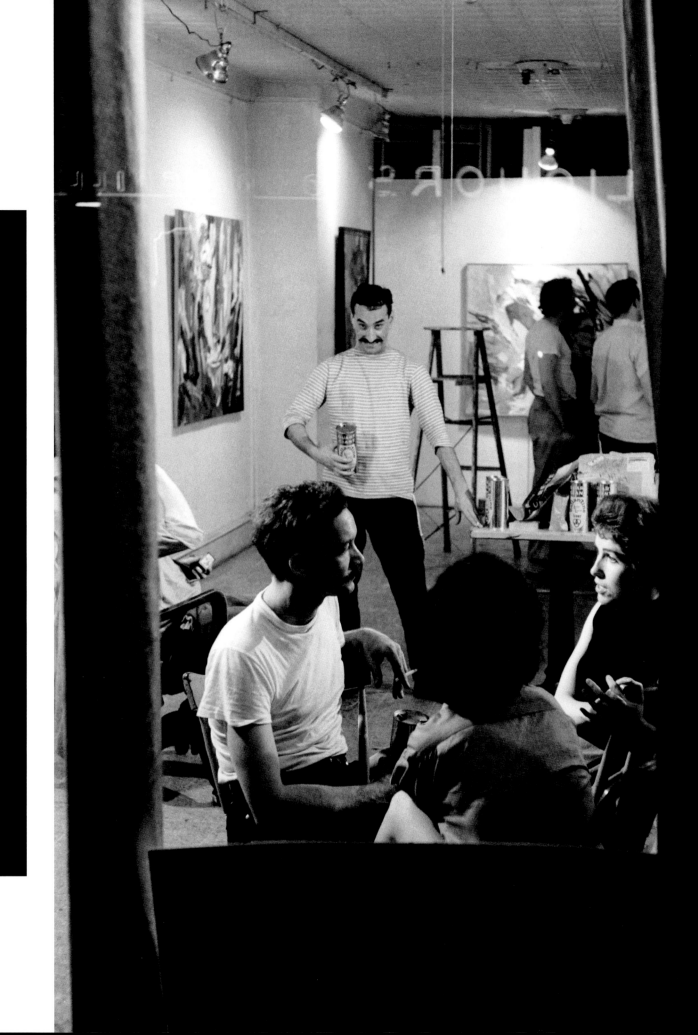

Cock-n-Bull is another Village coffee shop on Bleecker
Street. The gent in the dark glasses in the
foreground is one Dean Dexter, who wears his shades
continuously to protect him from the reefer glow.

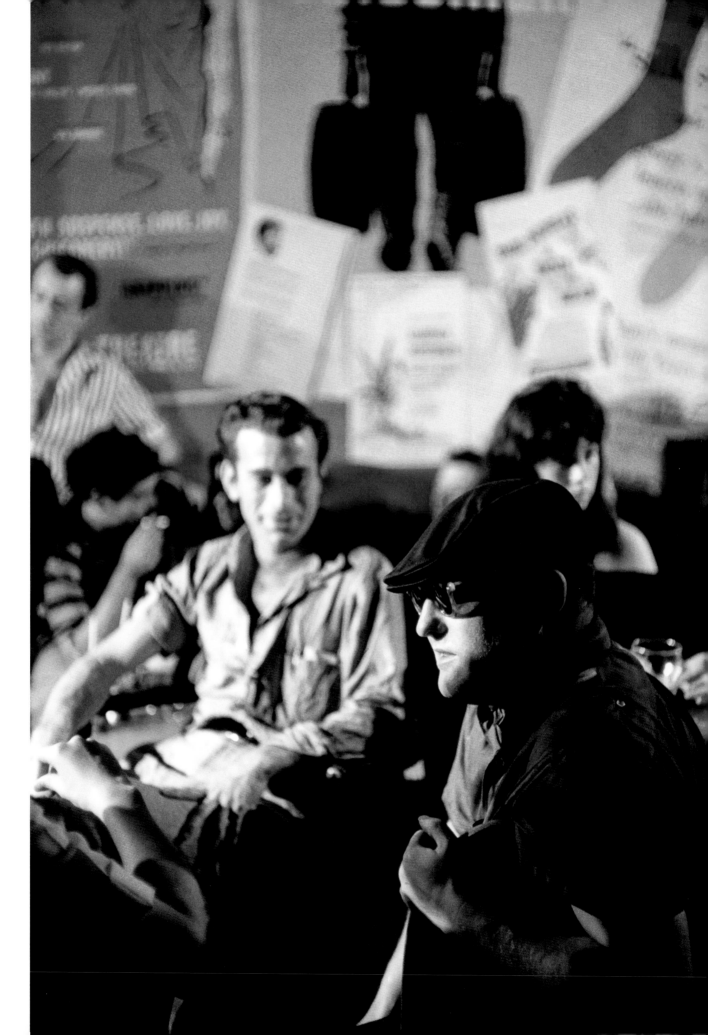

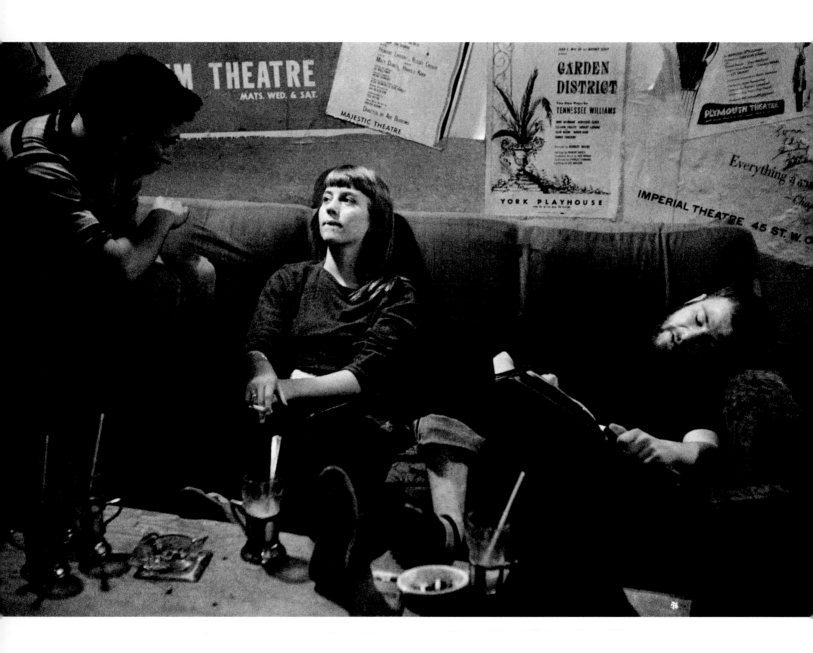

William Morris talks to a friend while Hugh Romney
gathers his thoughts. An evening among the hipsters
is alternately frantic and very hushed. One favourite retreat
for meditation is the coffeehouse Cock-n-Bull where
dogs and bare feet are not frowned on.

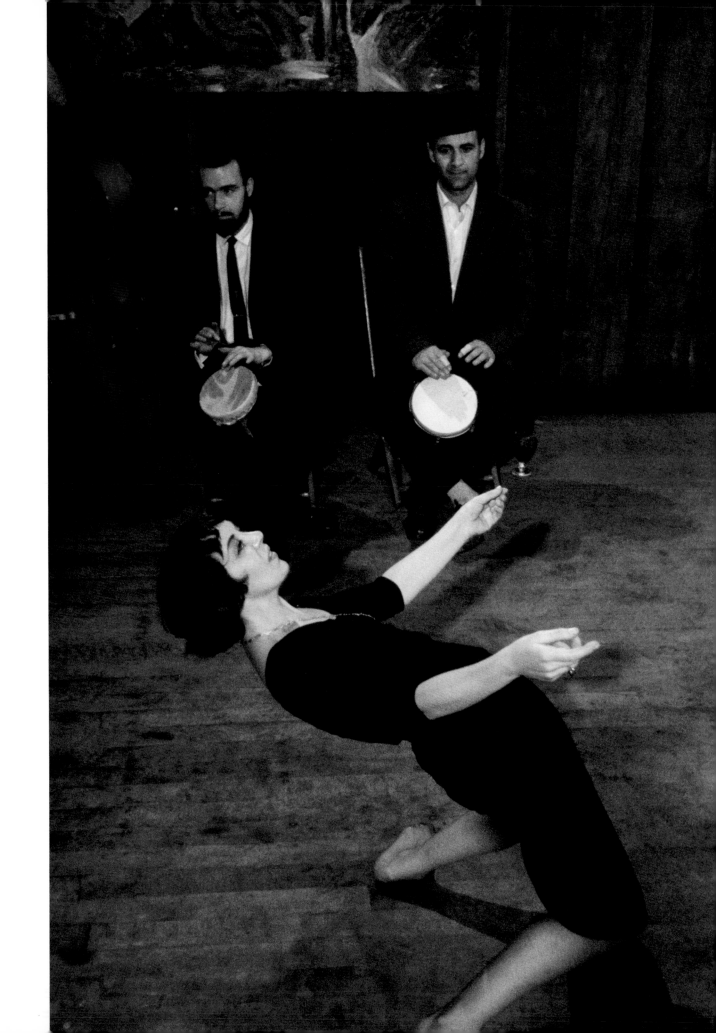

west coast beats 1960

A French dancer improvising to the music at a party at
artist David Stone Martin's studio loft apartment. The
band play with both Eastern and Western instruments.

Lawrence Ferlinghetti with Shigeyoshi "Shig" Murao, the manager
 of his City Lights bookshop. The City Lights is the mecca for all Beat writers
and many of them receive their mail there. The shop used to be a mission house, hence the
 sign on the wall unaltered in the past 50 years reading, "Remember Lot's Wife."

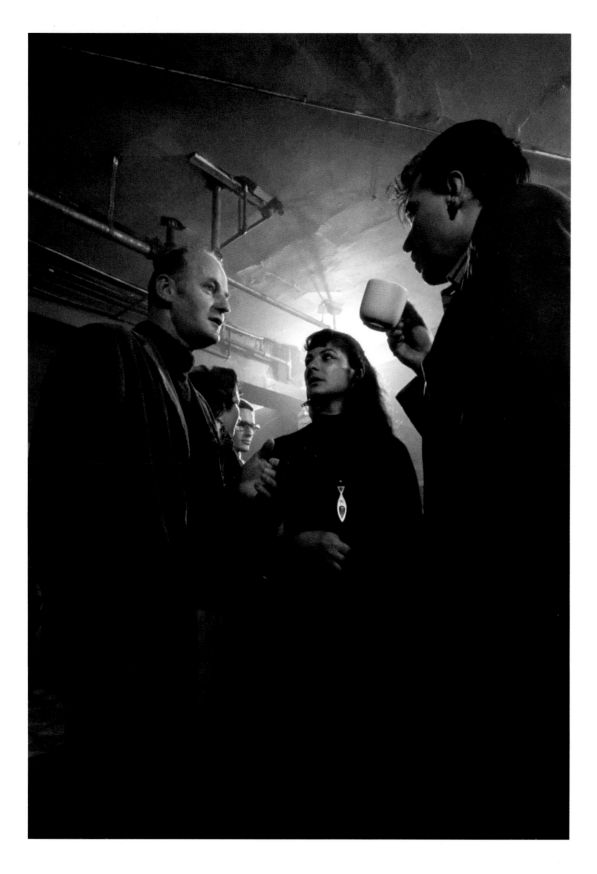

Party given by some artists in a Vallejo Street
cellar. The balding man on the left is Lawrence
Ferlinghetti. Mulled wine is served—the Beats' Dry Martini.

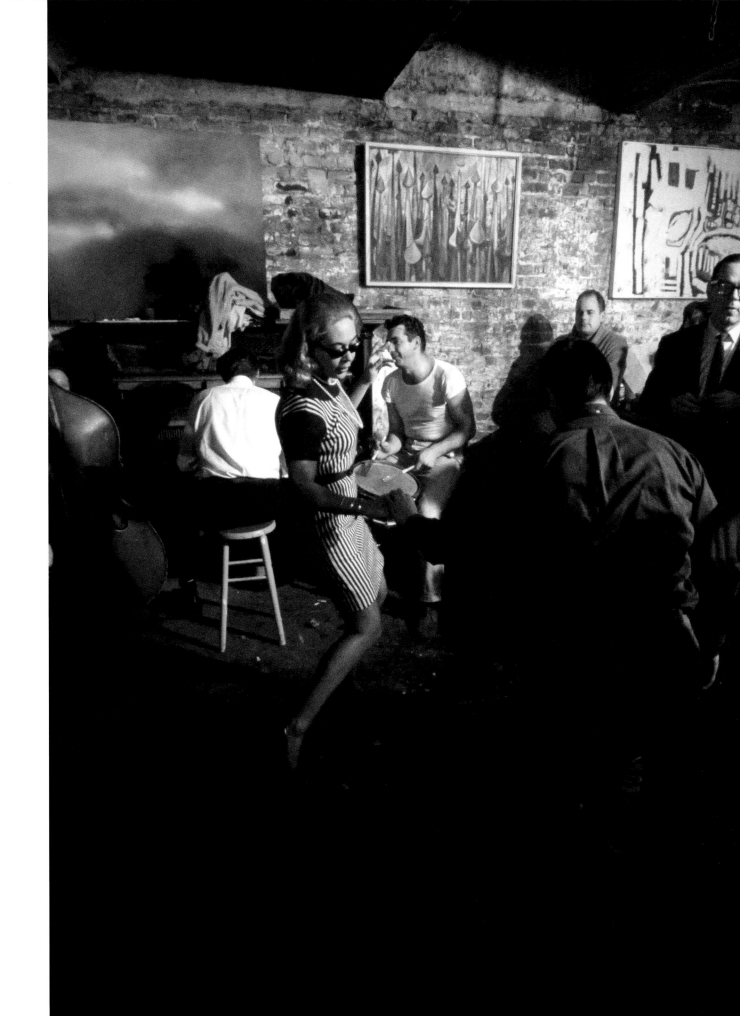

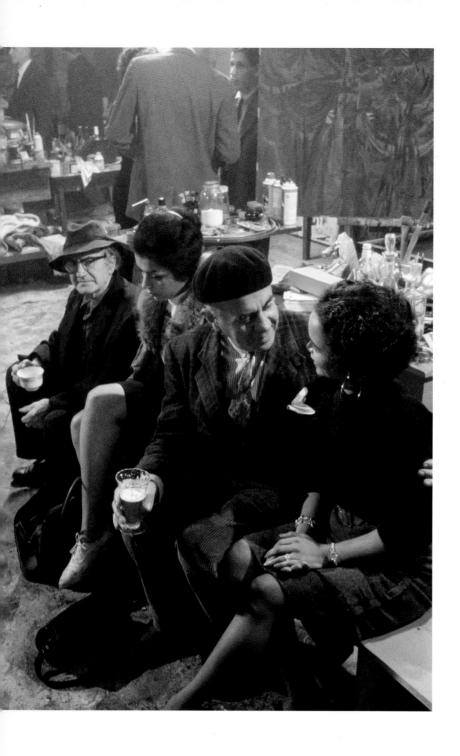

A girl is dancing in her slip and bra. Evidently, she found
clothing a bit restrictive. I got her to dress as soon
as I could. Later she sits with Karl Siegel, who claims
to be the first Hollywood stills photographer.
As far as I can see he is just a more lecherous Weegee,
which considering his age is remarkable.

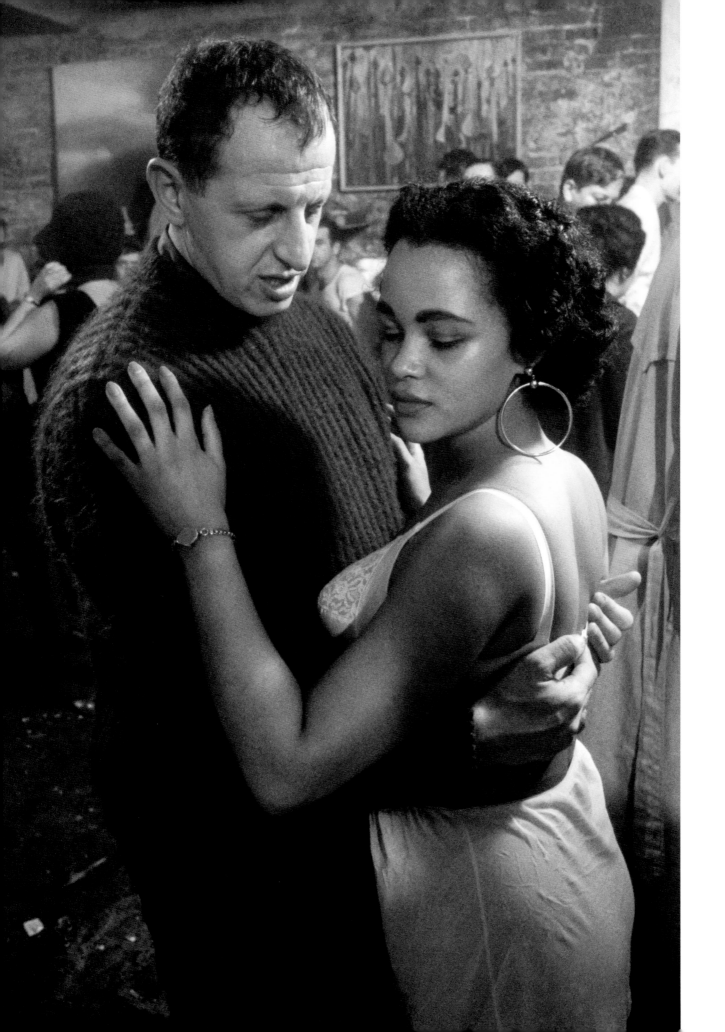

David Stone Martin gives swinging Sue Barton, a
 fashion model, a helping hand during a picnic at his party.

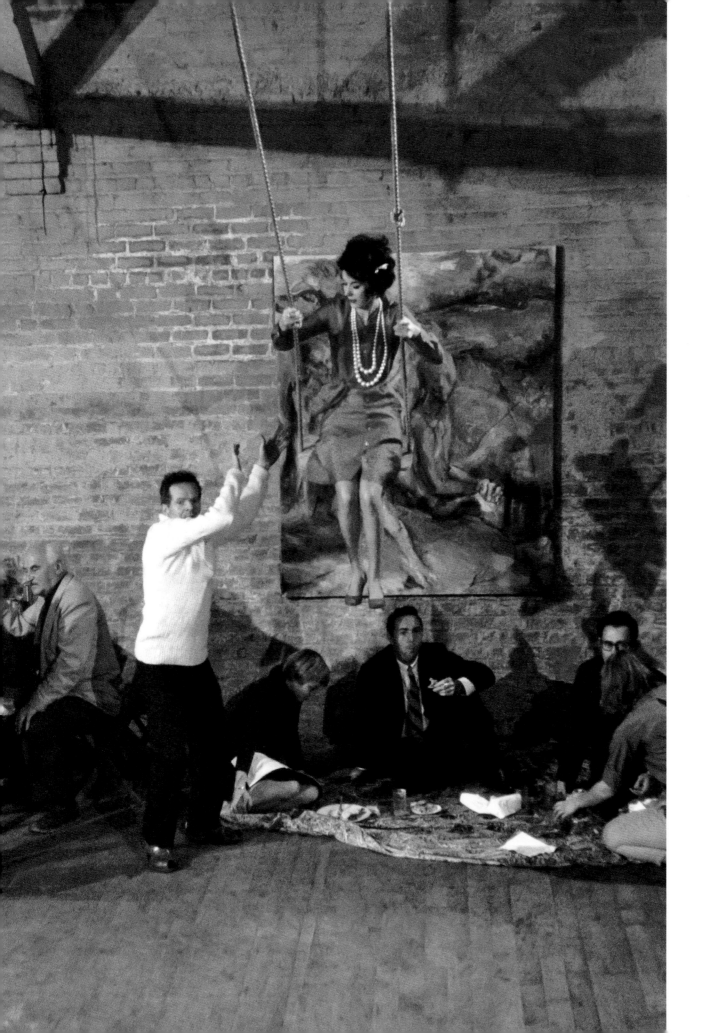

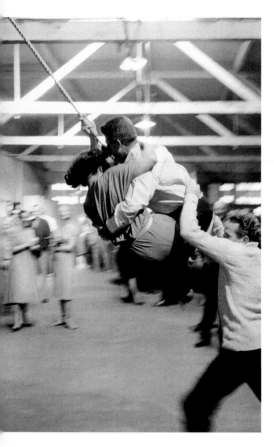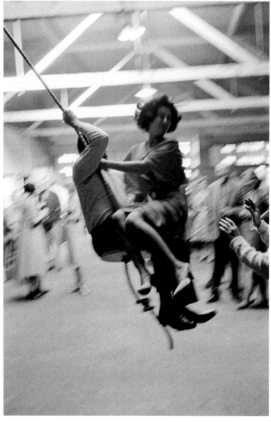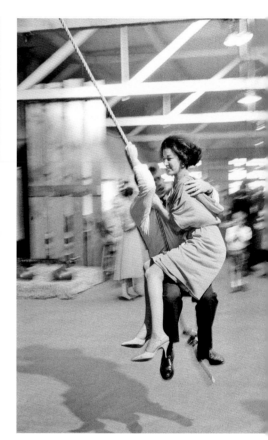

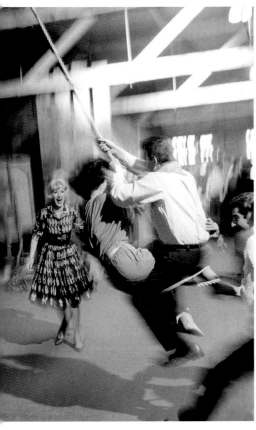

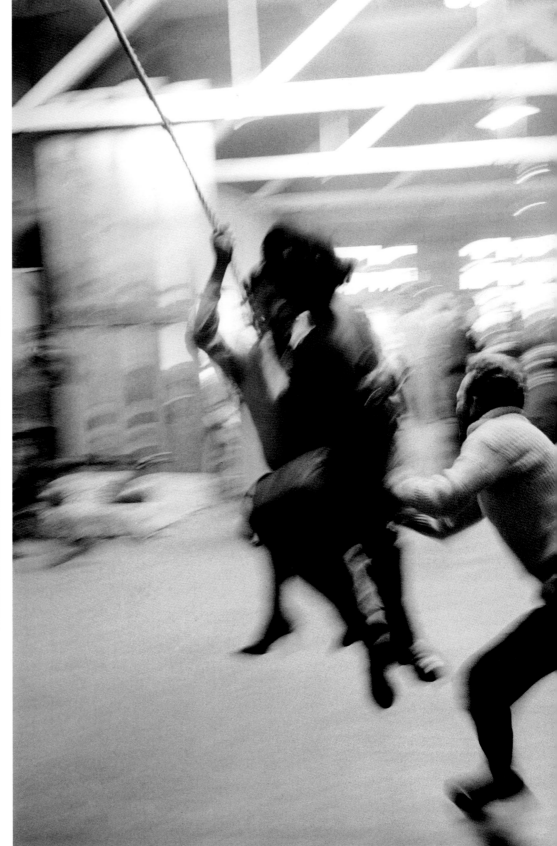

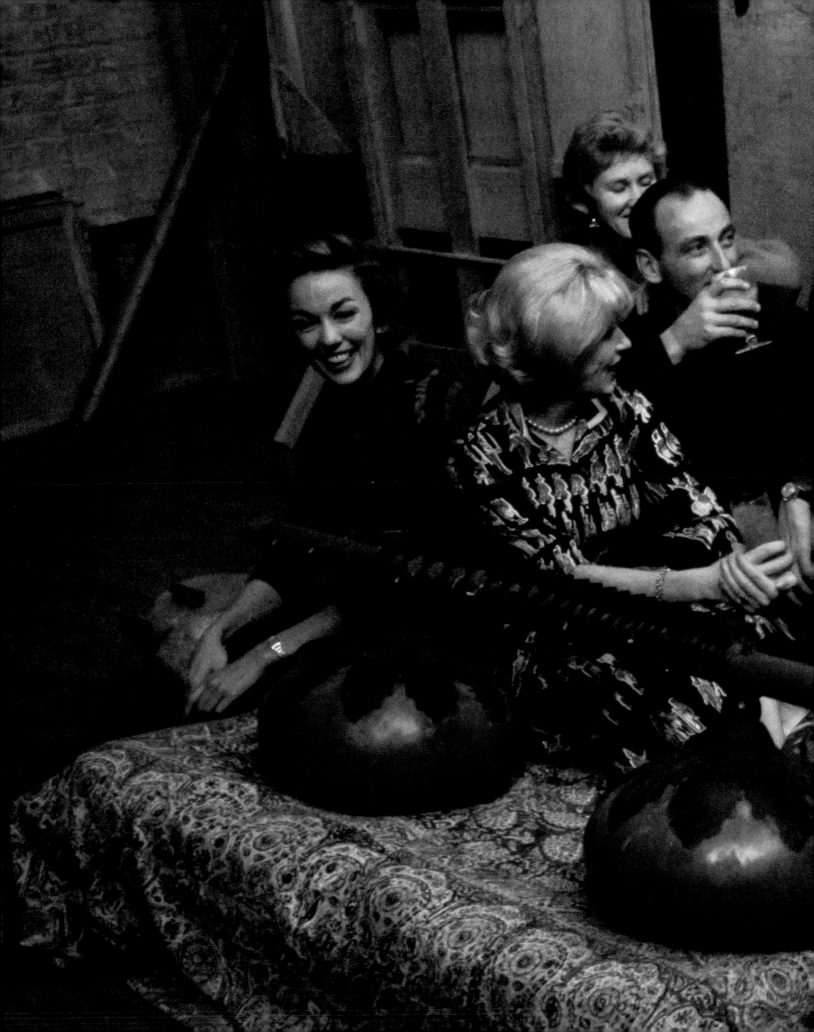

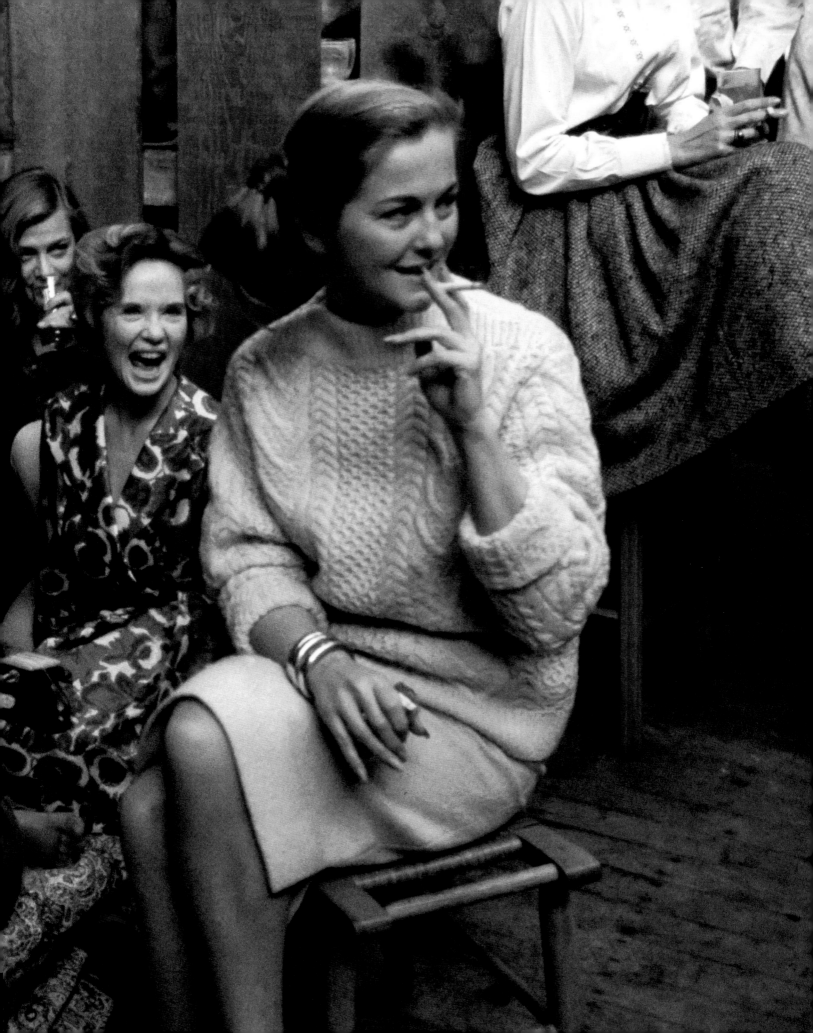

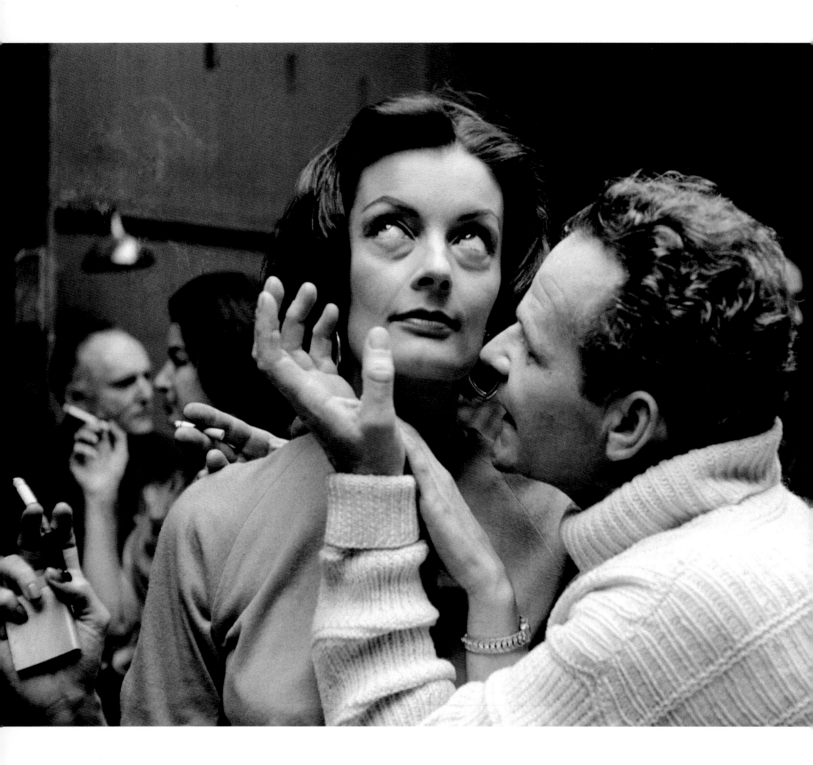

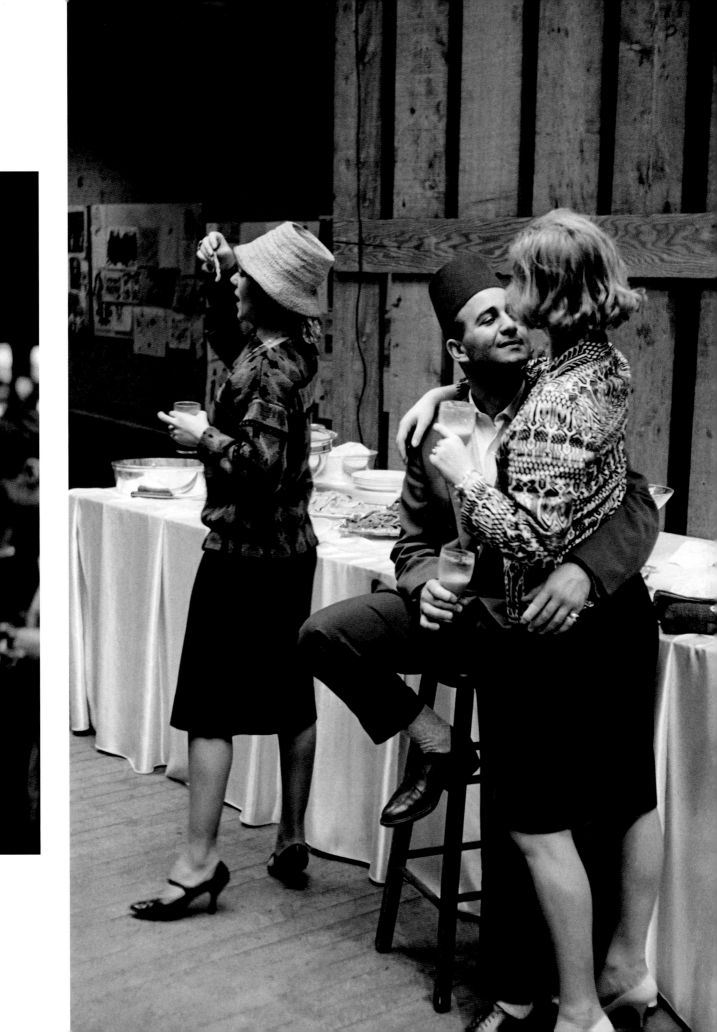

A chess interlude during a break in the revelry at the Blackhawk,
a night spot on the corner of Turk and Hyde Street where eminent
 jazz performers are often to be found in action. For the Beats, jazz is almost food
and drink. The player making the move here is Earl Bostic,
 virtuoso of the loud tone alto.

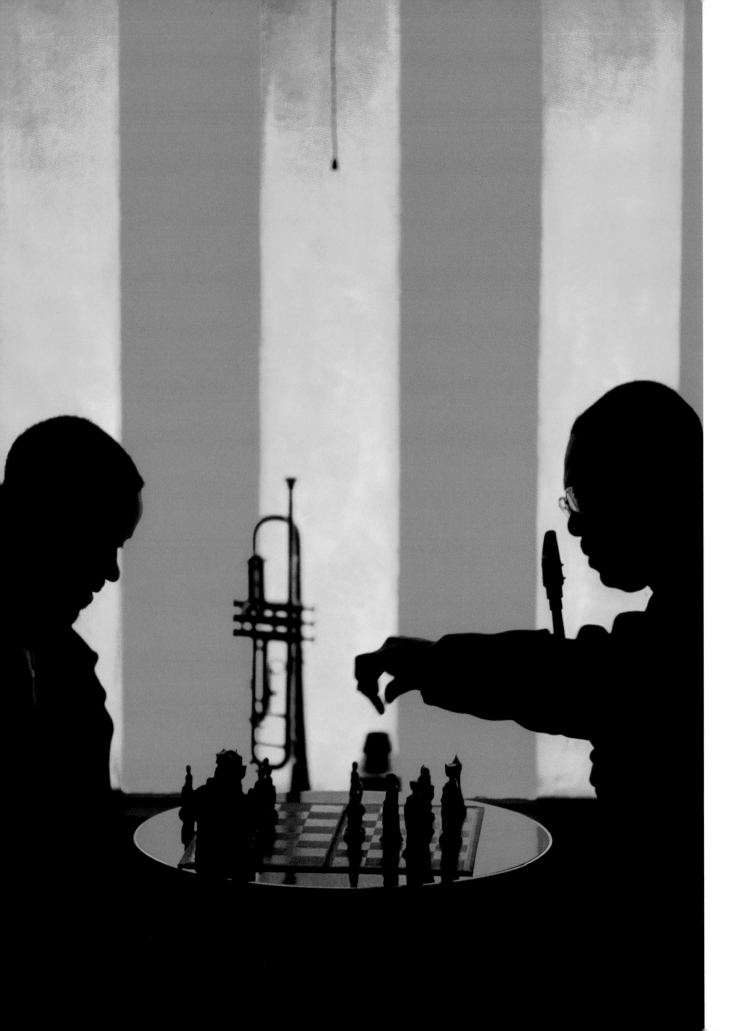

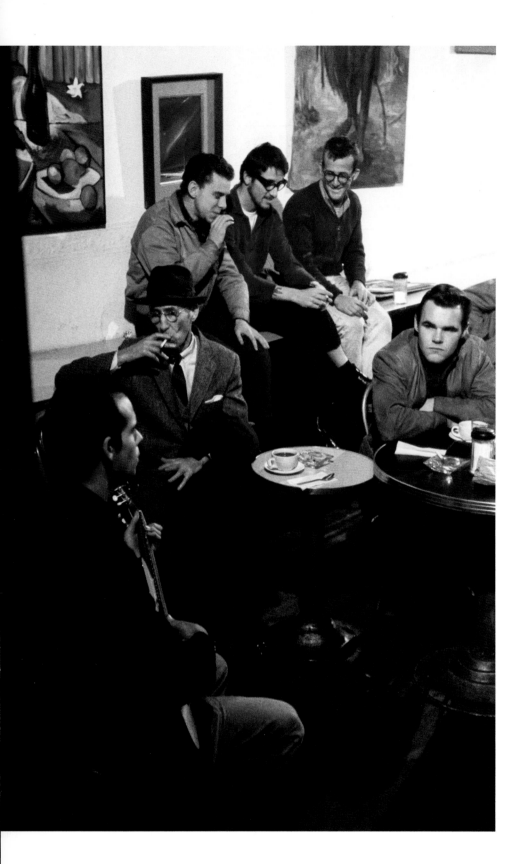

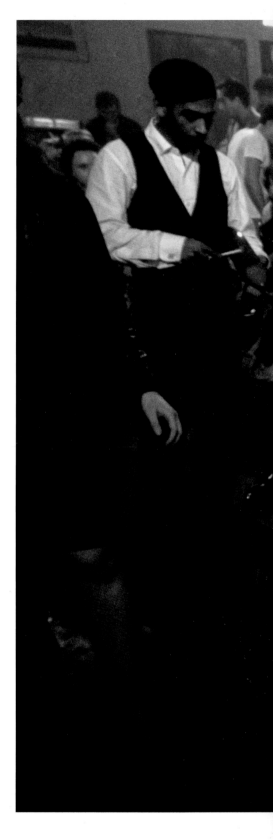

A new place on the beach called the Fox and
 Hound, where patrons can expect anything from
a folk recital, jazz to a bongo party.

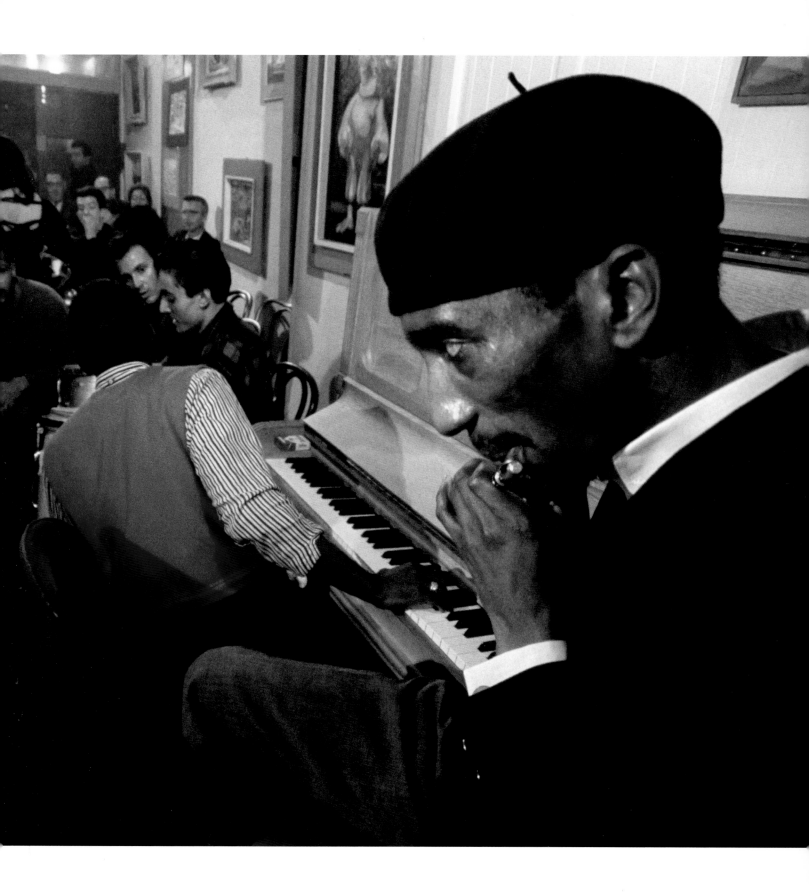

Getting into the groove at the Fox and Hound.

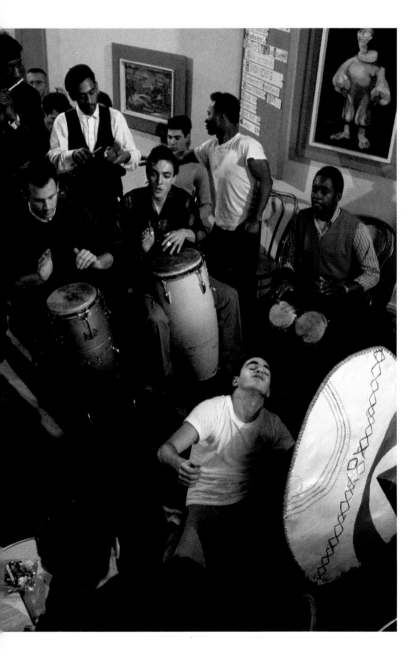 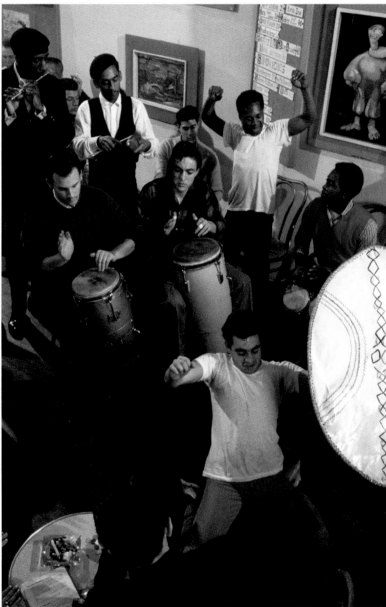

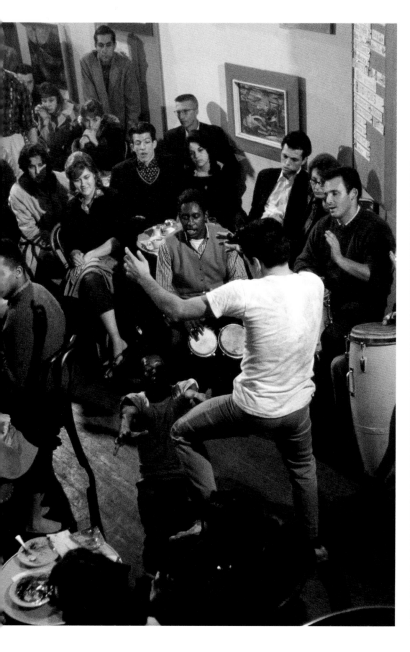

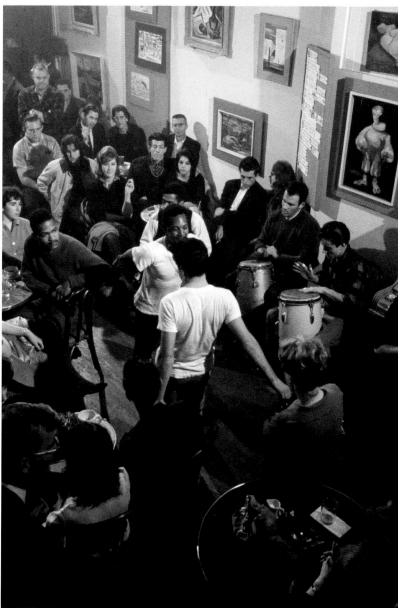

Diversions in the Beatnik scene frequently take the form of
a conversation. Outlandish hats are optional, and even beards are not
absolutely de rigueur. The amiable chat here is taking place at the
Coffee Gallery and might concern almost anything
from parapsychology, through the poetry of Allen Ginsberg,
to the good old days.

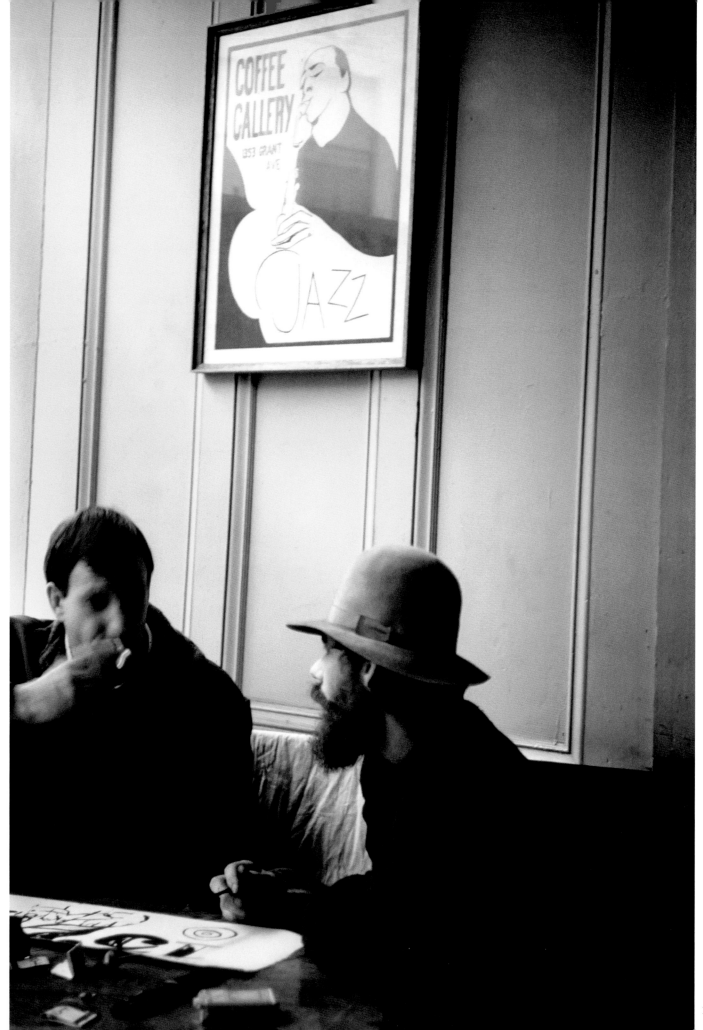

Gathering at the houseboat home of
Jean Varda, San Francisco painter
who is as well known for pretty girls
as he is for painting. That
is his bottle sculpture on the window.

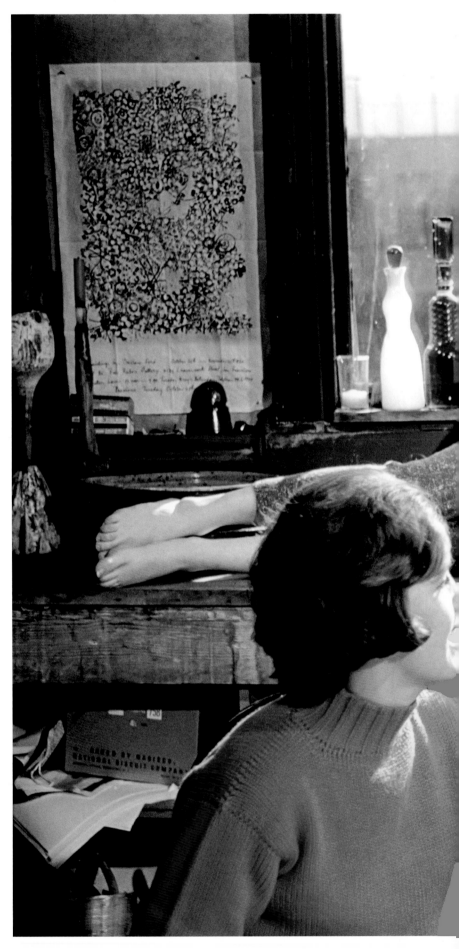

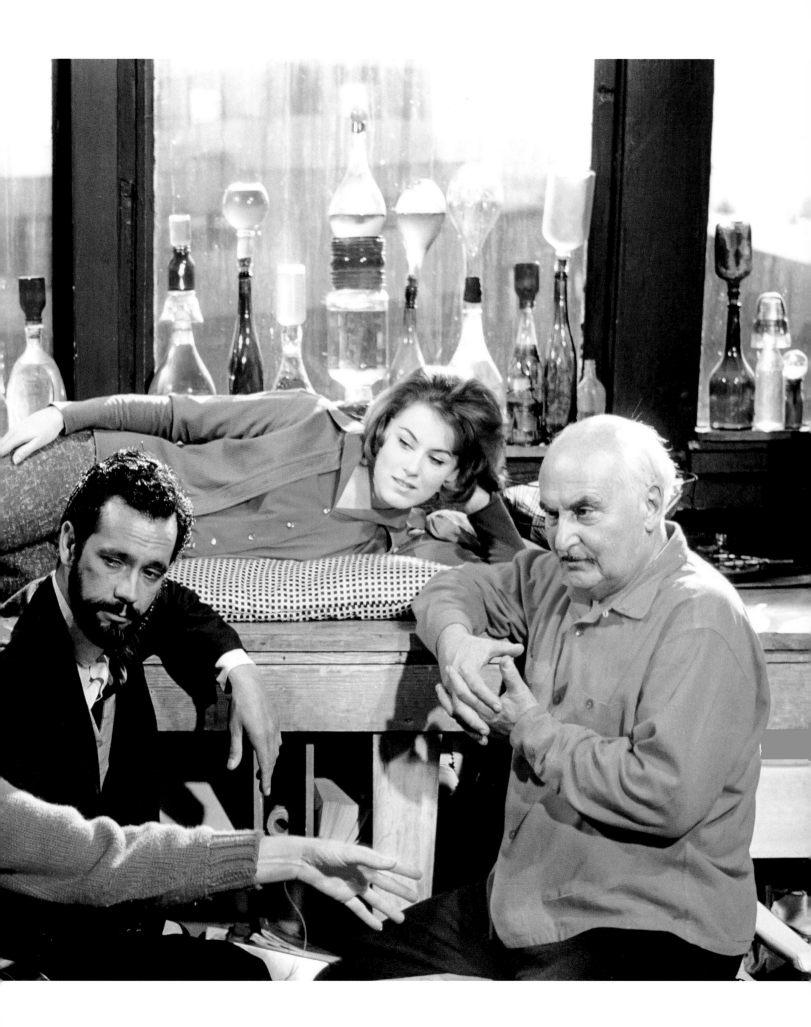

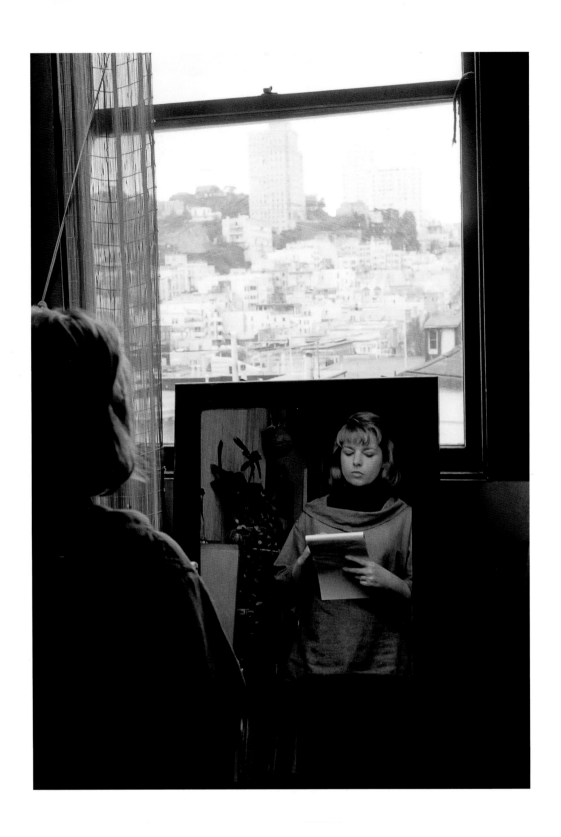

Artist Emily Eugenia "Nemi" Frost does a self-portrait
 sketch in mirror in front of window in her Harwood Alley pad.
(Opposite) Judy Smith is a painter and guitar player
 and very much a part of the North Beach scene.

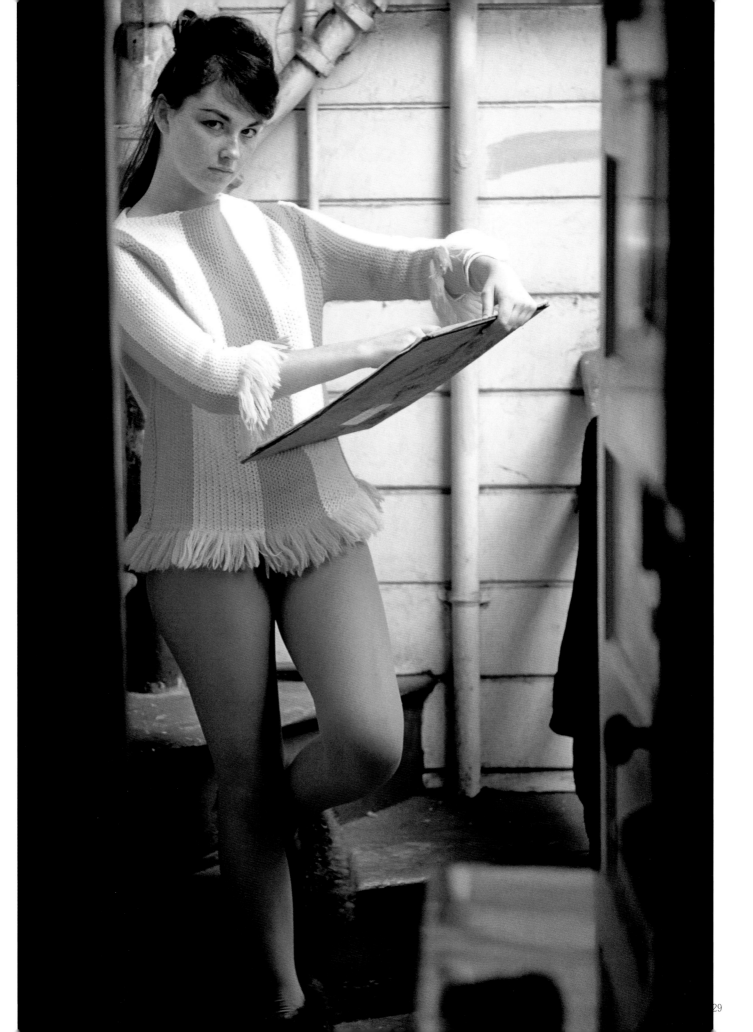

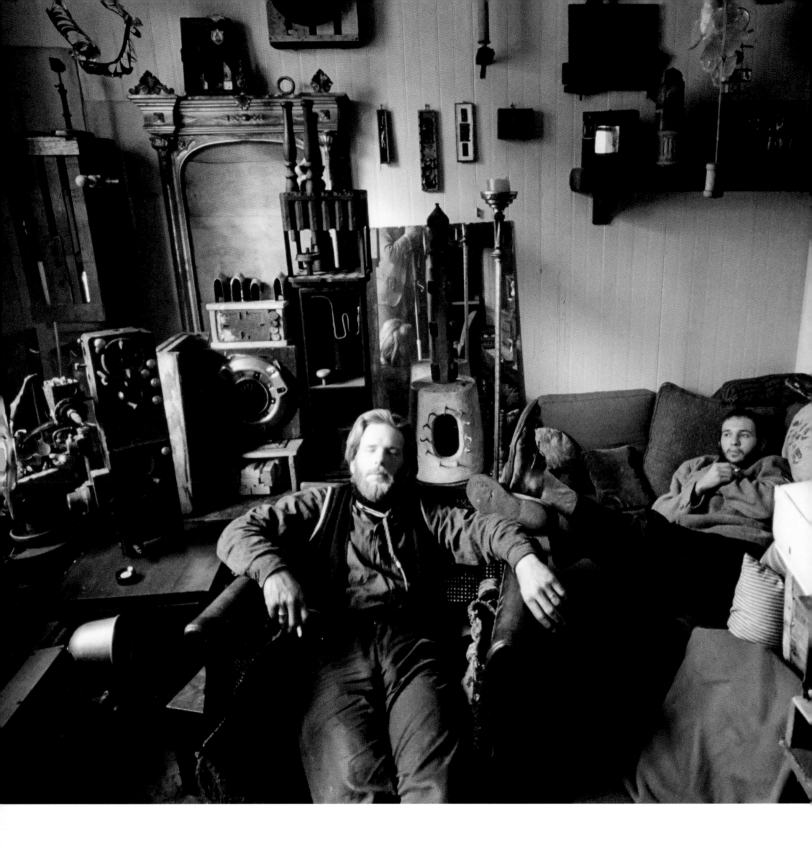

John Gibbon and his friend Jerry in his Harwood Alley pad.
The room, as John explains, is a piece of living sculpture as
he adds to it every time he finds something new. He considers himself
of the Louise Nevelson school of sculpture. (Opposite)
John and Jerry with "Nemi" Frost in Harwood Alley.

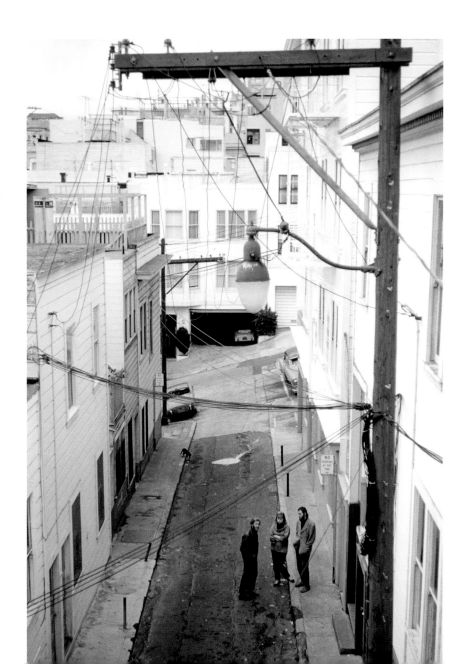

Gavin Arthur, grandson of the former President
of the United States. He lives in a small hotel room
surrounded by these astrological charts and
makes his living by casting horoscopes.

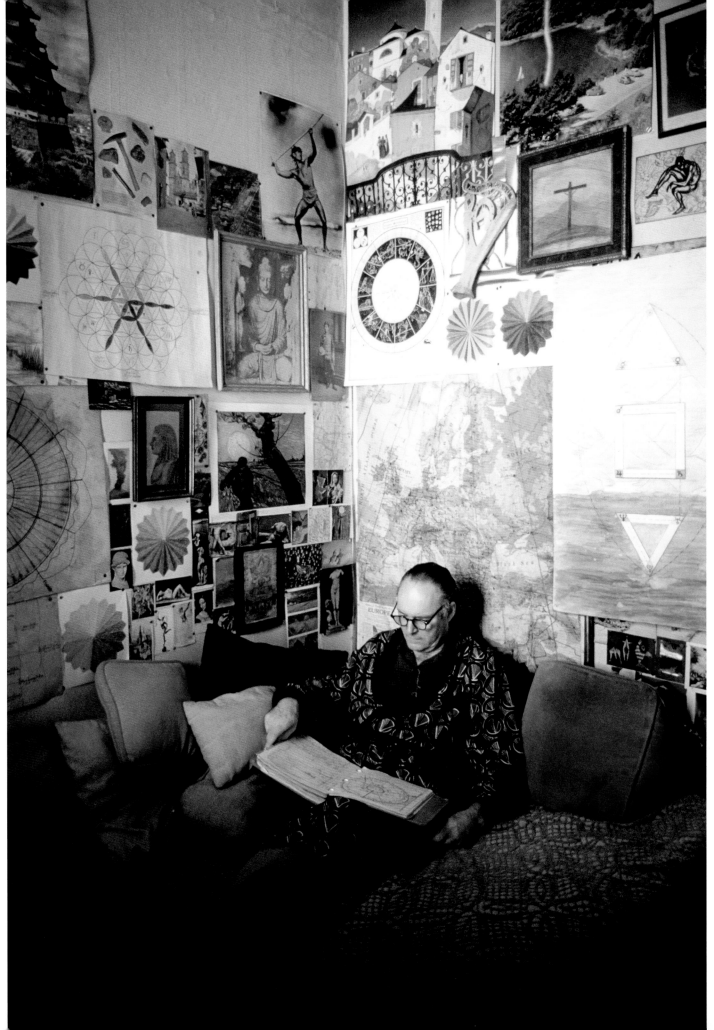

Jay DeFeo, one of San Francisco's most successful younger
artists, at work on her latest painting "Deathrose", a heavily
encrusted oil painting, eleven feet by eight. She has been working
on this for more than two years. As you can see the girl is pretty good.
This painting is the best I've seen here, and better
than most of those I saw in New York.

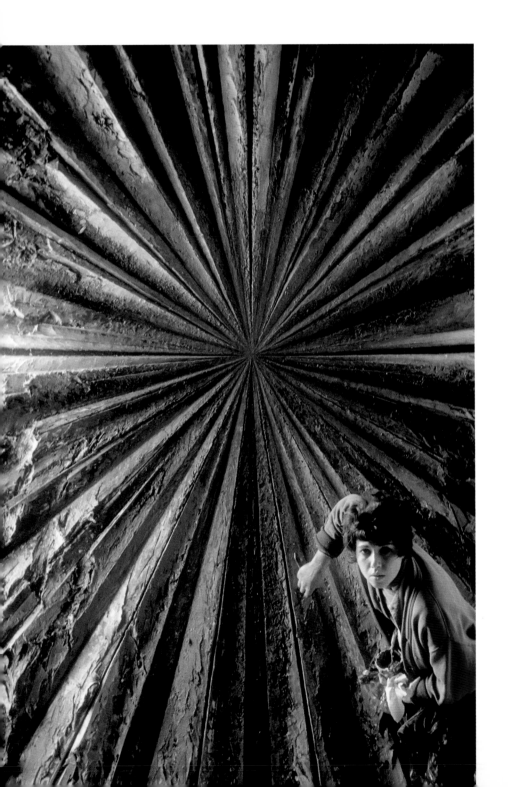

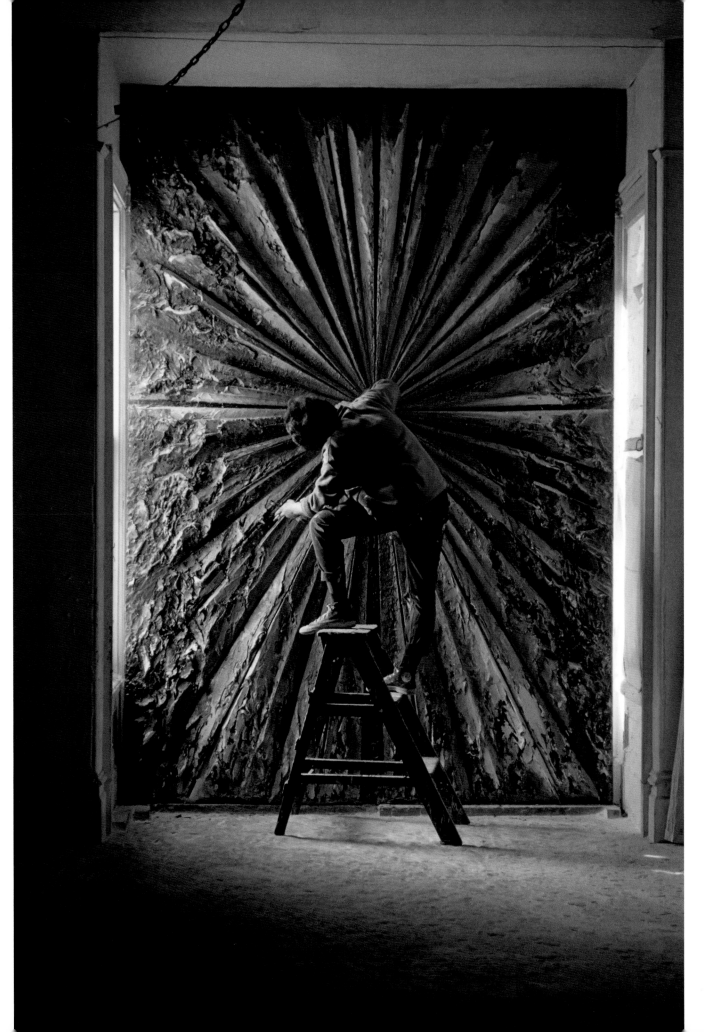

Pre-Conceptualist artist Wally Hedrick stands
next to his latest artwork and with his painter
wife Jay DeFeo in the hallway of their home.

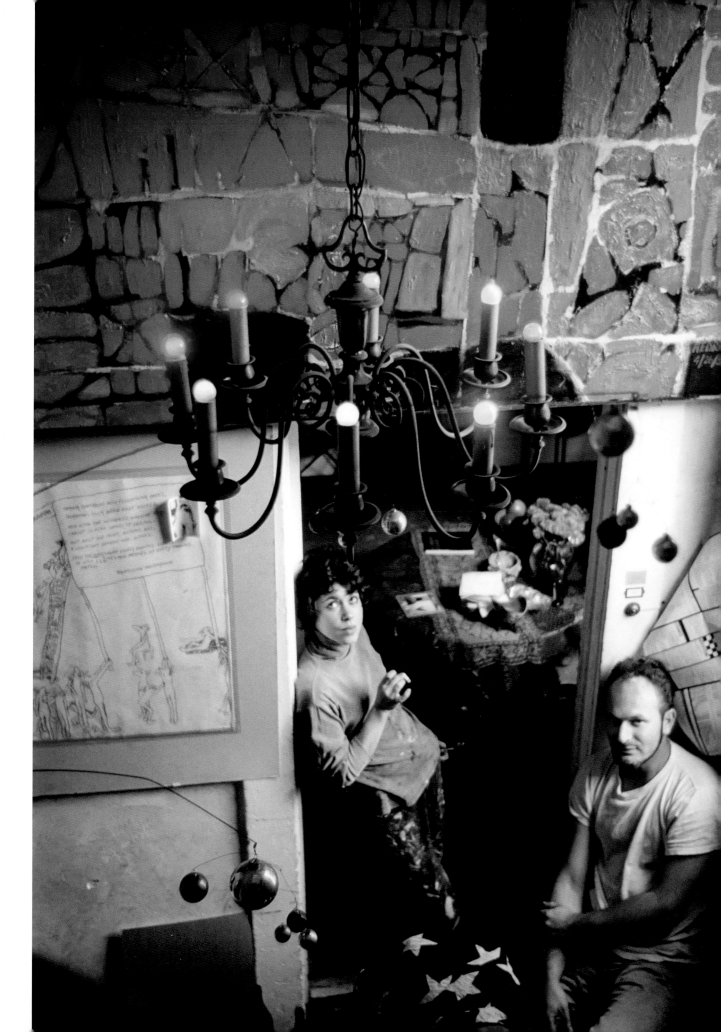

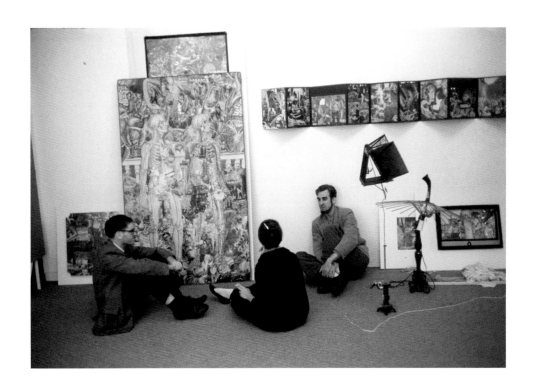

The hanging of a collage show at the Dilexi gallery. The collagist
is Jess Collins with the gallery owner Jim Newman. Jess is the one with
the beard and has high hopes for his work (above and opposite) titled "The Sun: Tarot XIX".

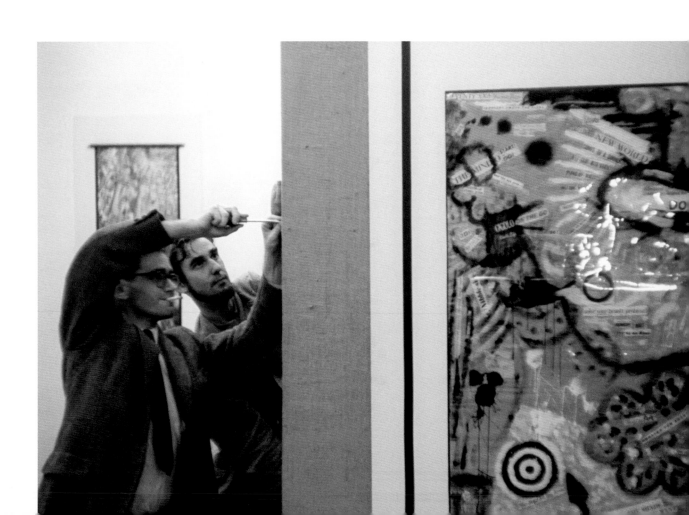

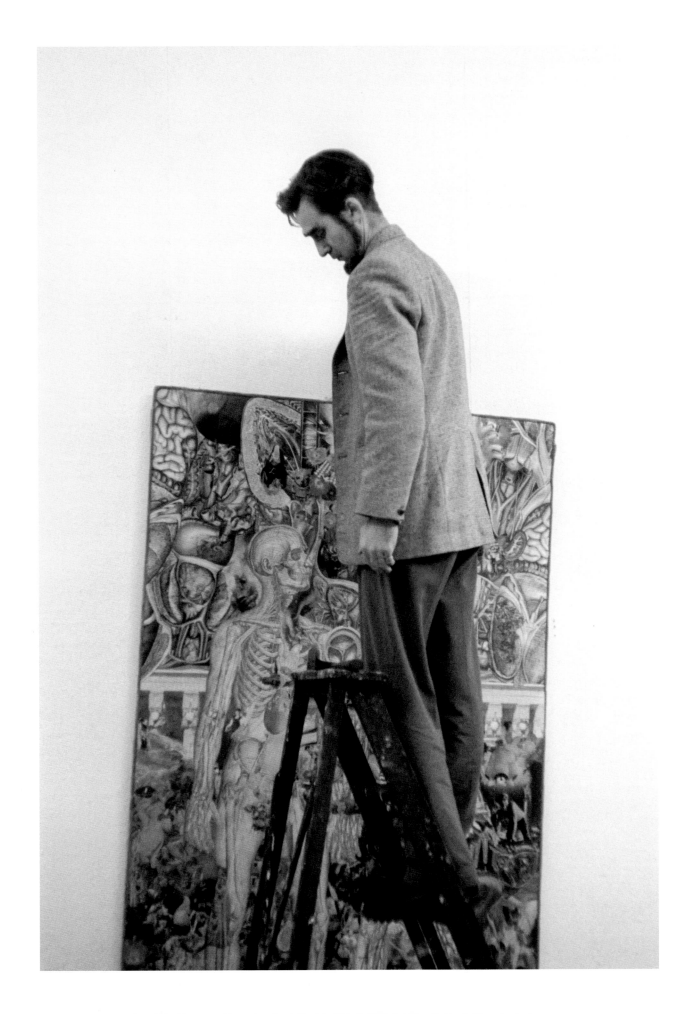

Nude model Virginia Campbell-Butler in the studio
of painter Casey van Duren. This is a basement studio in the heart
of North Beach. She is a native of England but has
been in the US for 11 years and is well known
in the North Beach scene.

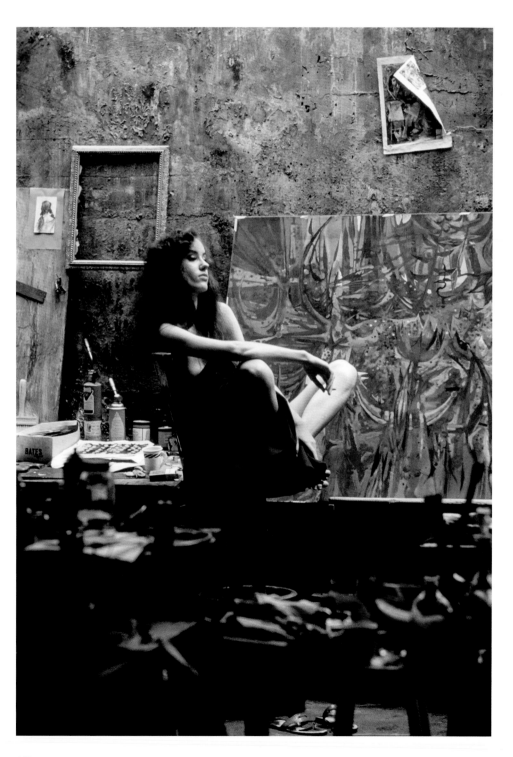

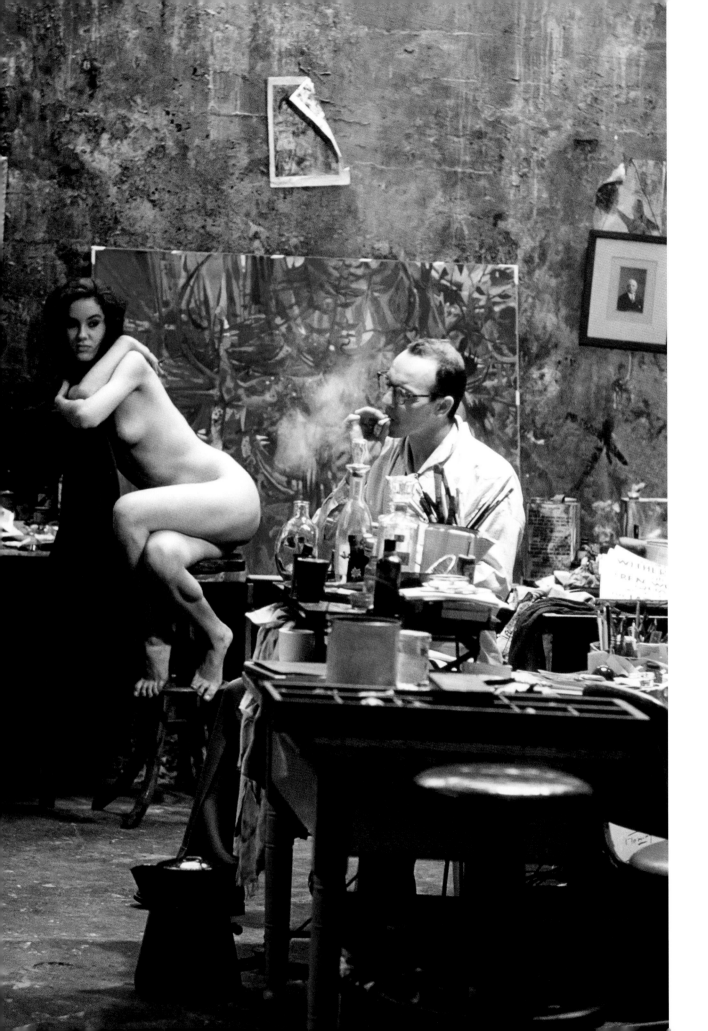

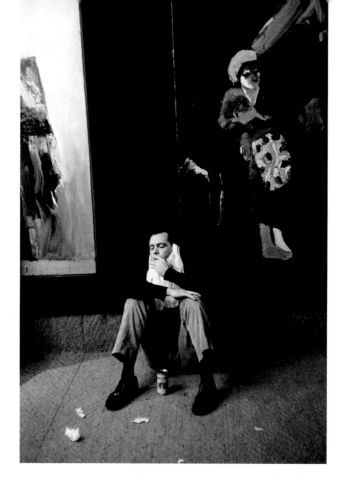

The Batman Gallery opened on November 3, 1960, with walls painted black by Bruce Conner,
and a poetry reading by Kirby Doyle with owner William Jahrmarkt "Billy Batman"
presenting Michael McClure's play "The Feast!" with a gypsy-like crowd who
are both screwy and civilised. They are dedicated artists who model their
lifestyles on the work of Robert Duncan and Wallace Berman. (Opposite) Wallace Berman
(beard and scarf), his sculptor wife Shirley (with cigarette), and their young son Tosh.

 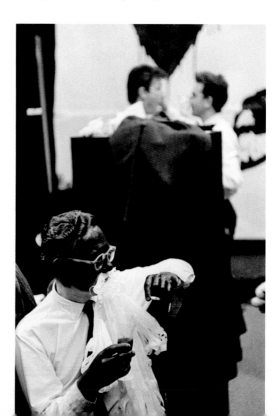

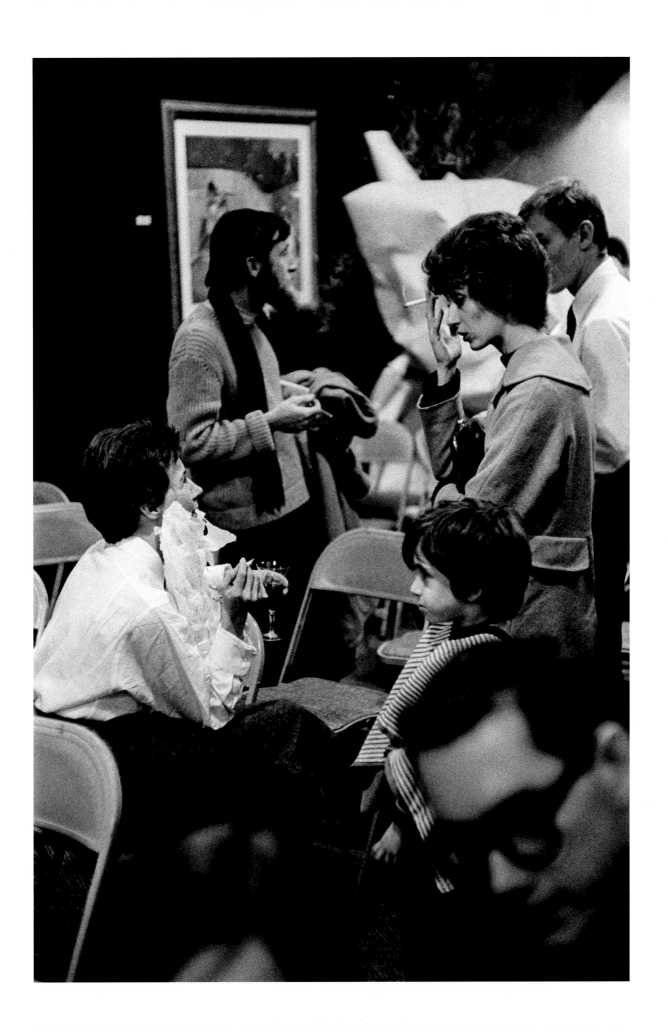

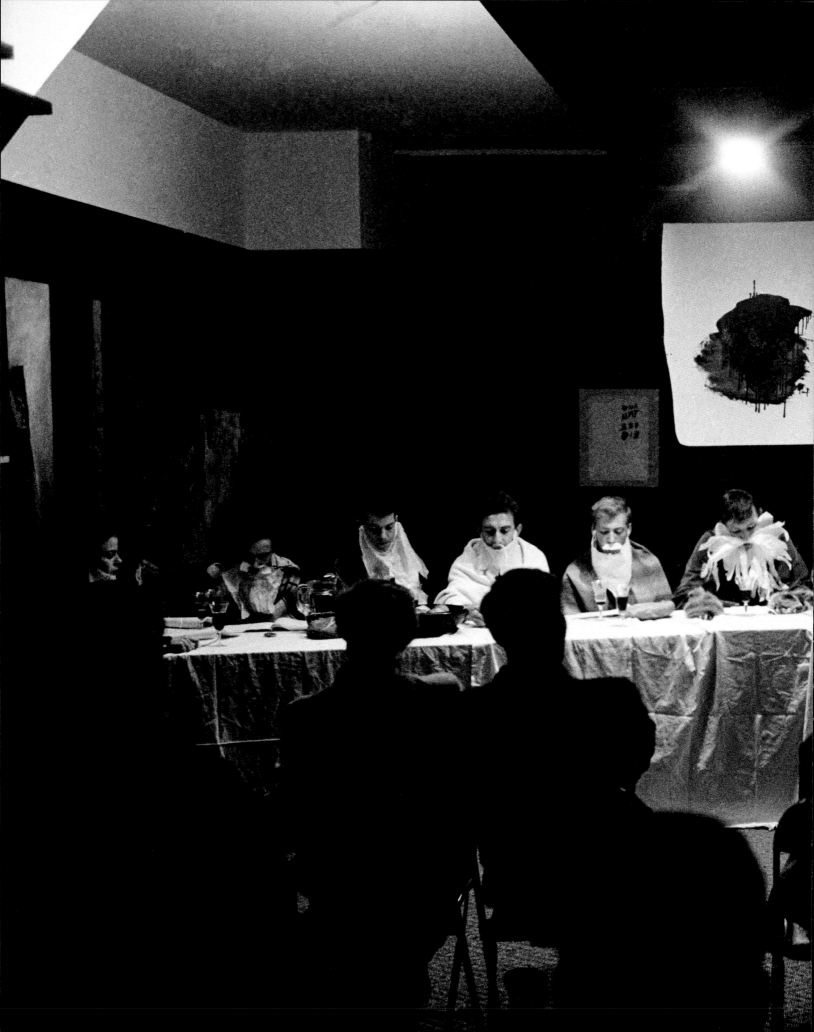

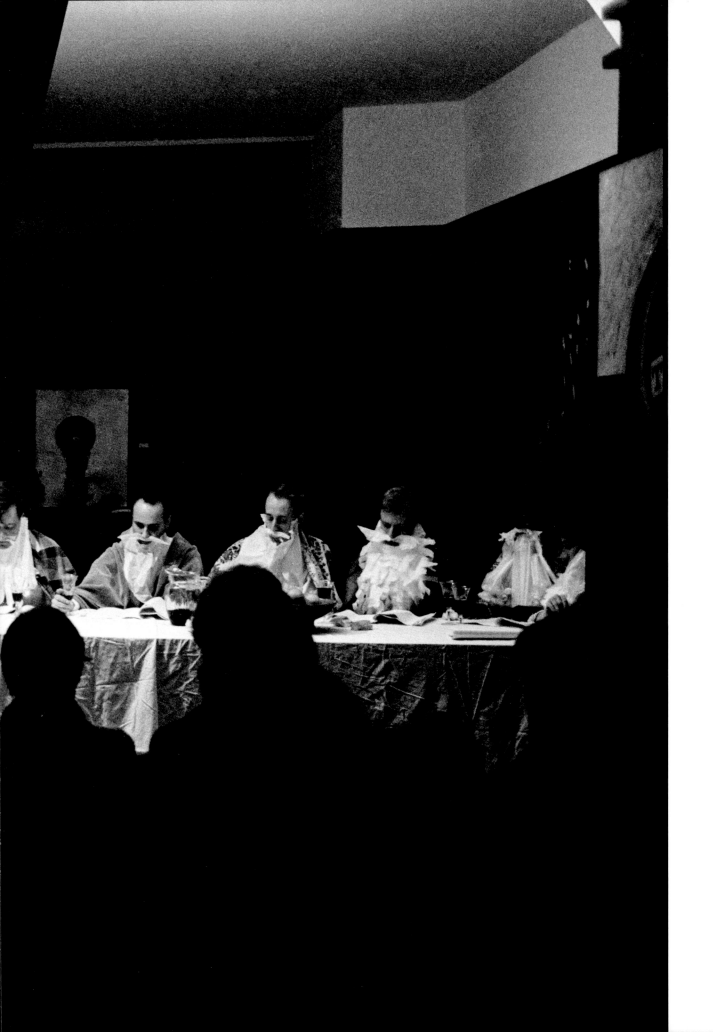

Enrico Banducci, impresario of the Hungry i nightclub
in North Beach, which has become famous for
launching the careers of many performers.

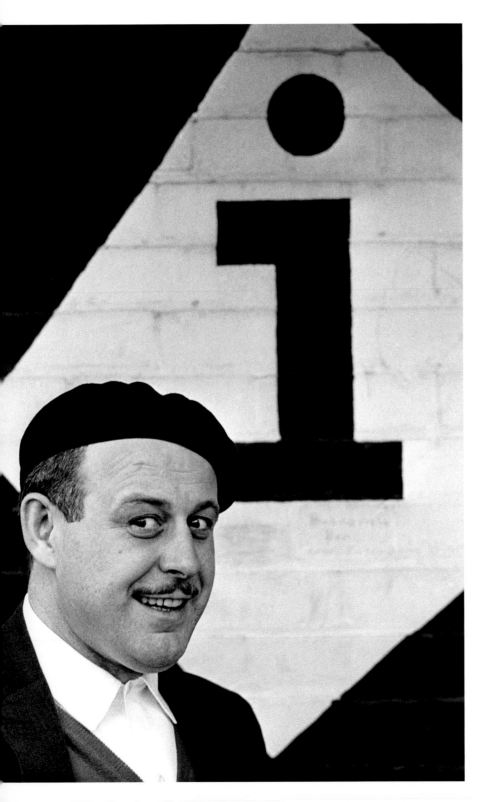

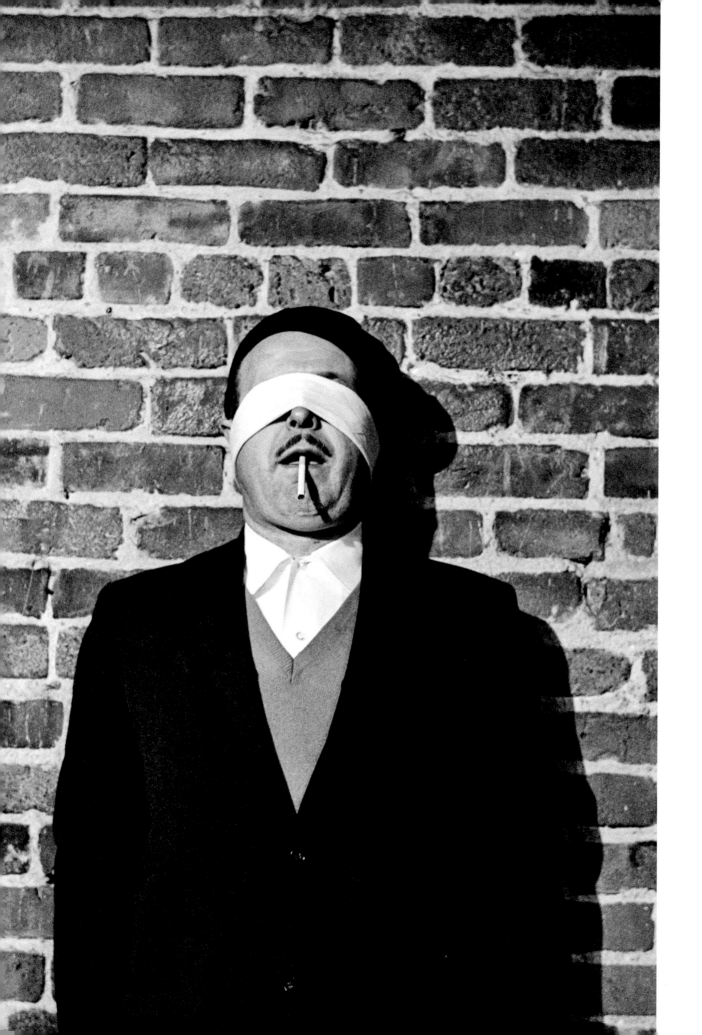

Mr. and Mrs. Roger Somers, who take their Zen
 seriously, are seen relaxing in the Japanese-style
shrine which they put together themselves.
 The objects on the table (the one in the middle
is a bird's nest) are memorials to their musical gods,
Charlie ("Bird") Parker and Ludwig van Beethoven.

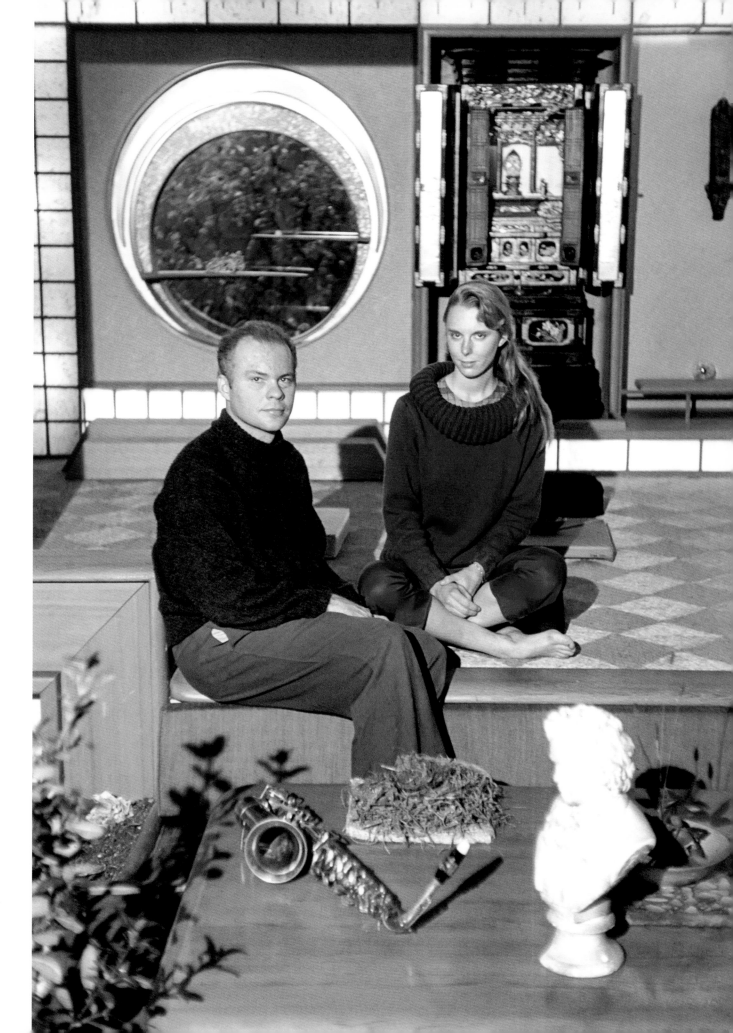

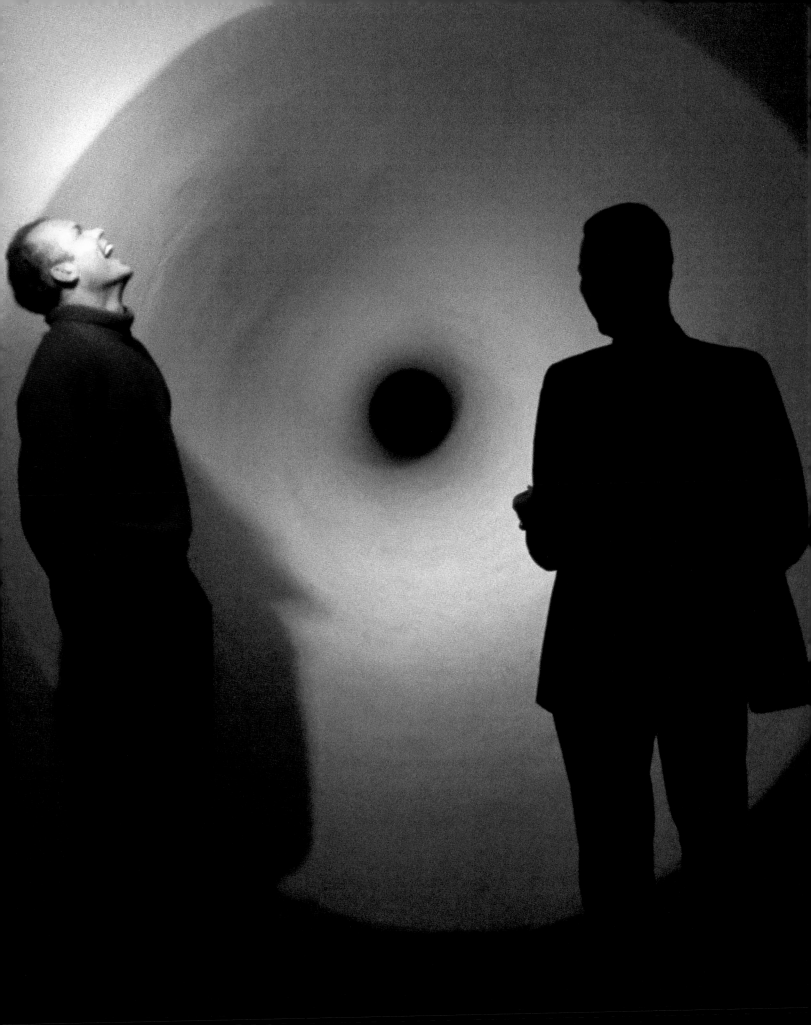

Alan Watts (left), the local high priest of Zen, with
Roger Somers silhouetted against the giant amplifying horn
in the studios of Musical Engineers Associates.
His delight comes from hearing himself coming out of the horn
reading Japanese haikus.

Recording session in MEA Studios. Vincent Delgado
is playing a Japanese shamisen, Alan Watts is reading
on the right and Henry Jacobs, one of the partners of MEA,
is sitting inside the horn. The gentleman with his
back towards us is Roger Somers.

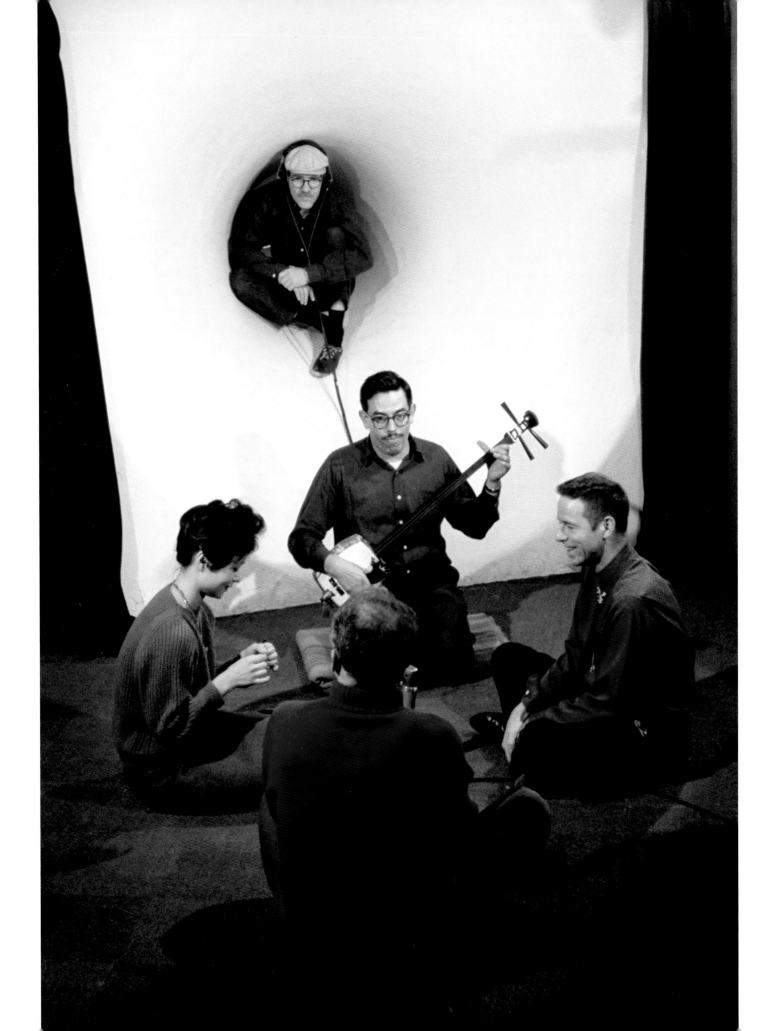

Jamming session, Zen style, at MEA Studios.

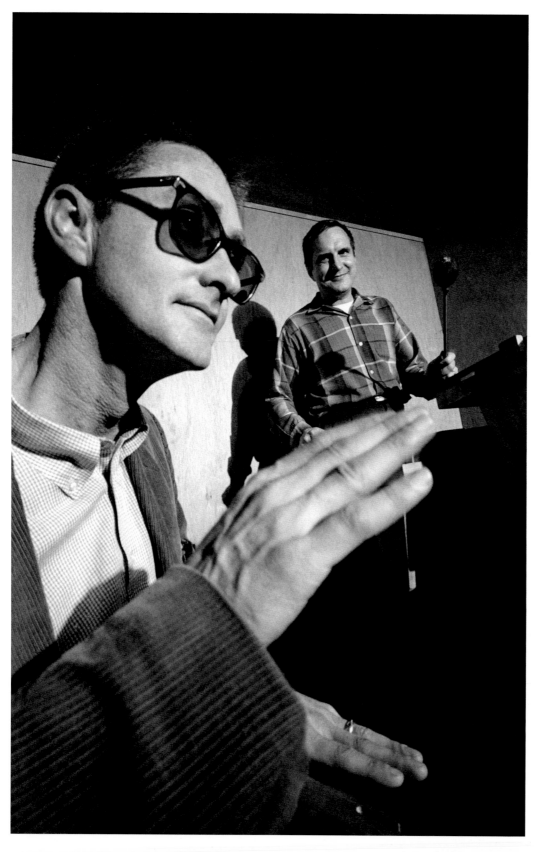

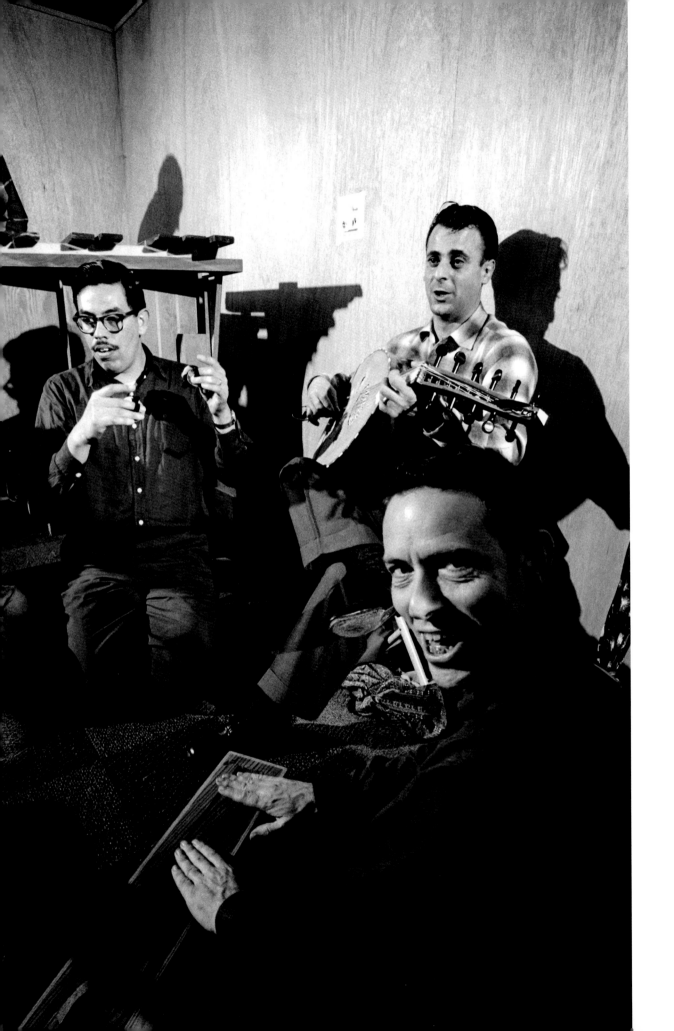

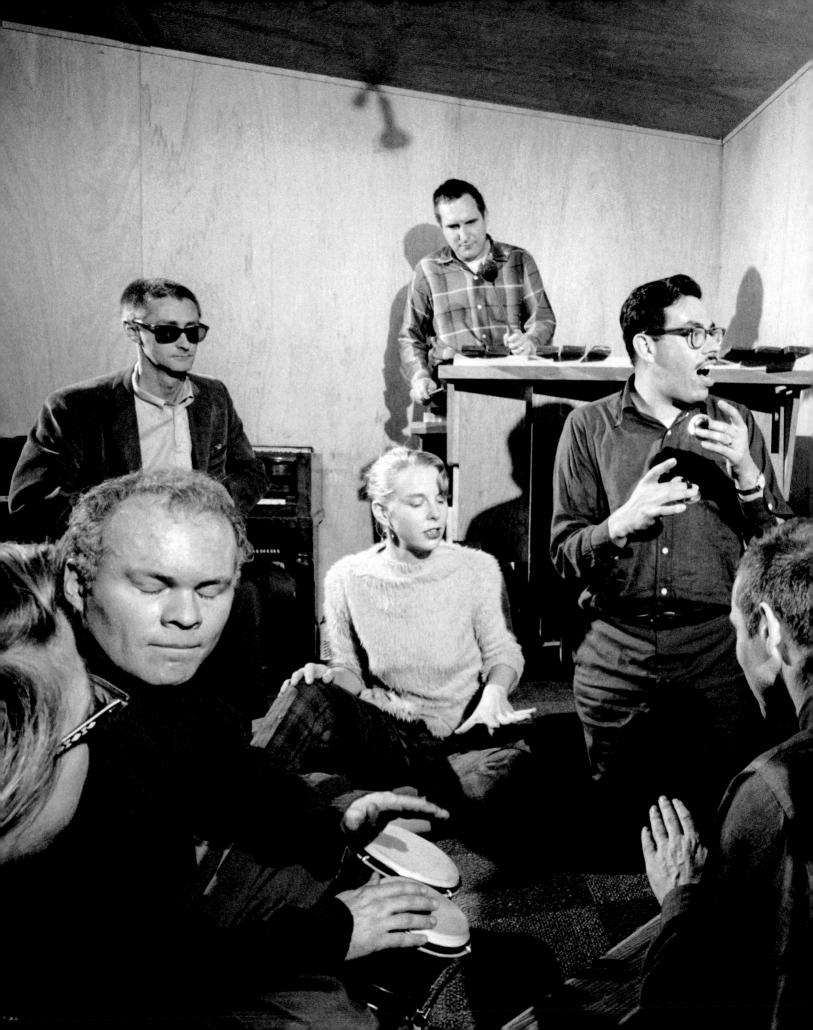

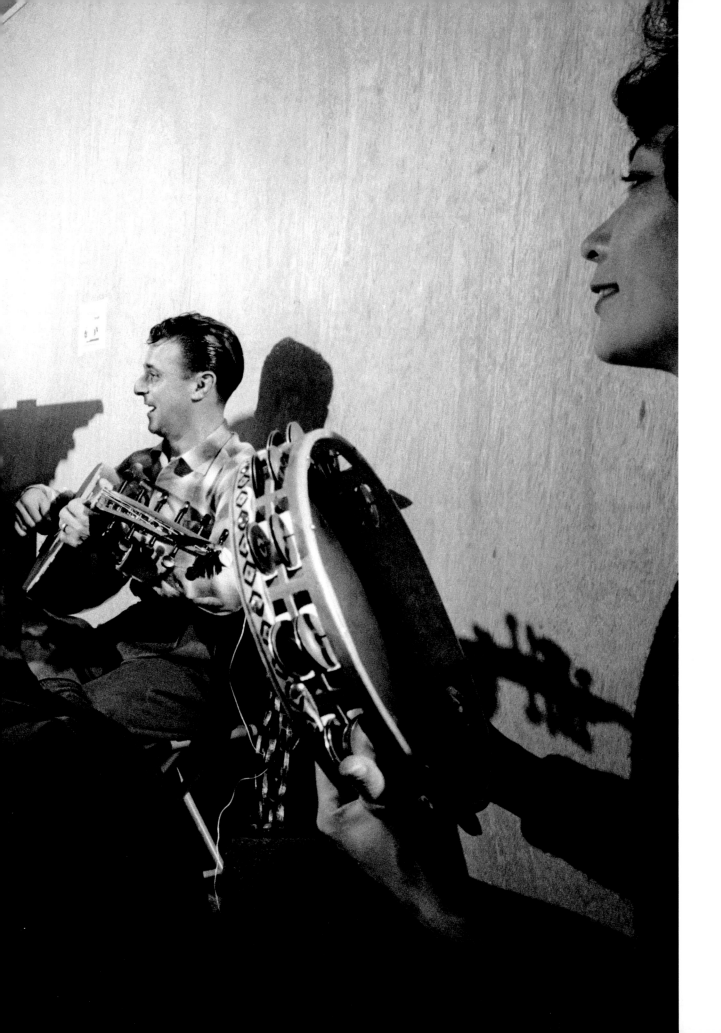

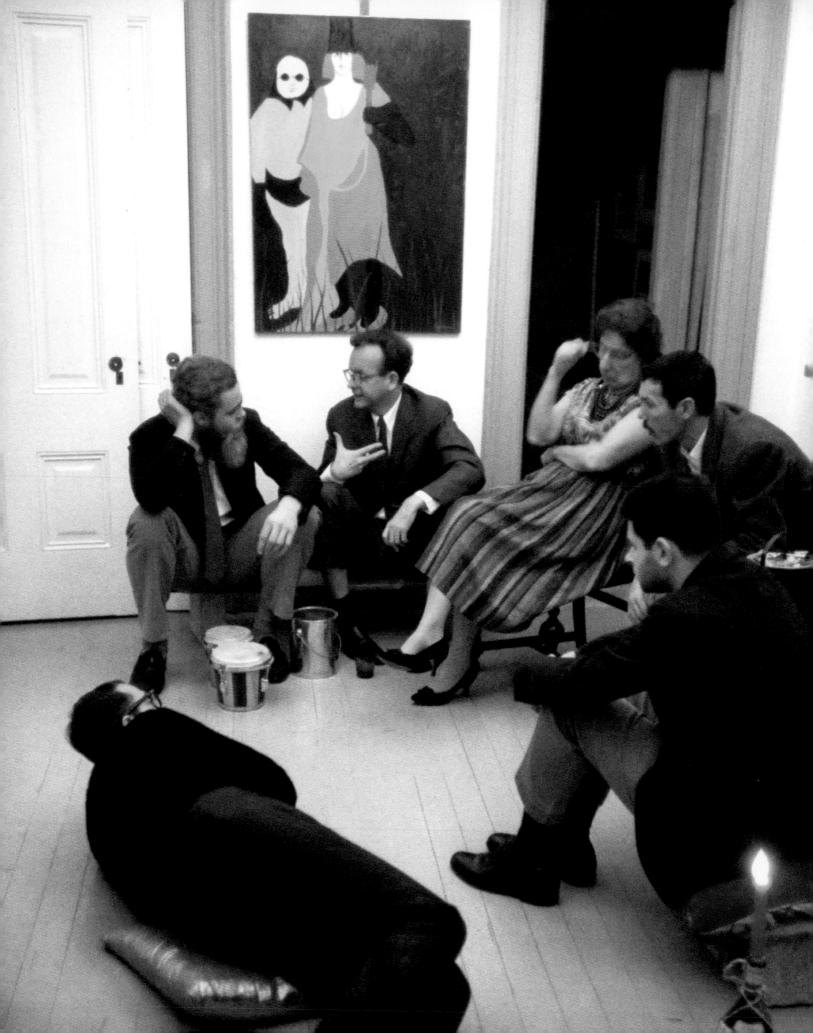

Photo Index

First published 2018 by Reel Art Press, an imprint of Rare Art Press Ltd., London, UK

www.reelartpress.com

First Edition 10 9 8 7 6 5 4 3 2 1

ISBN: 978-1-909526-26-6

Pre-Press by HR Digital Solutions

Printed by Graphius, Gent.

Corso

170 E 2d

50

N O N A G O N

ROCCO ARMENTO ANNE ARNOLD RONALD BLADEN ILYA BOLOTOWSKY
LEE BONTECOU WARREN BRANDT J ANTHONY BUZZELLI JEAN CLAD
EDWARD CLARK ROLLIN CRAMPTON JANE BRASWELL CRAWFORD
JACK DAVIS WILLEM DE KOONING ROBERT DE NIRO GEORGE
DWORZAN JOHN FERREN MILES FORST JOHN FRANK MARY FRANK
SEYMOUR FRANKS WILLIAM FREED SIDEO FROMBOLUTI JAMES
GAHAGAN WILLIAM GAMBINI GERRY GARSTON JOHN GRILLO PHILIP
GUSTON BURTON HASEN DOROTHY HELLER HANS HOFMANN ANTHONY
IPPOLITO REUBEN KADISH ARISTODEMOS KALDIS MATSUMI
KANEMITSU EARL KERKAM FRANZ KLINE RICHARD KLIX AL KOTIN
STANTON KREIDER JOHN KRUSHENICK GEISHA KURAKIN ISRAEL
LEVITAN WILLIAM LITTLEFIELD VINCENT LONGO BORIS LURIE
MARCIA MARCUS STEVE MONTGOMERY GEORGE MORRISON DOROTHY
MULLER CONRAD MALLICOAT RAY PARKER FELIX PASILIS EARL
PIERCE MILTON RESNICK A SCHLEMOWITZ THERESE SCHWARTZ
WILLIAM SEBRING SALVATORE SIRUGO RONALD SLOWINSKI NORA
SPEYER RICHARD STANKIEWICZ MYRON STOUT ANNE TOBACHNICK
IRWIN TUTTIE RUTH VODICKA SAM WEINER FLORENCE WEINSTEIN
ROCCO ARMENTO ANNE ARNOLD RONALD BLADEN ILYA BOLOTOWSKY
LEE BONTECOU WARREN BRANDT J ANTHONY BUZZELLI JEAN CLAD
EDWARD CLARK ROLLIN CRAMPTON JANE BRASWELL CRAWFORD
JACK DAVIS WILLEM DE KOONING ROBERT DE NIRO GEORGE
DWORZAN JOHN FERREN MILES FORST JOHN FRANK MARY FRANK
SEYMOUR FRANKS WILLIAM FREED SIDEO FROMBOLUTI JAMES
GAHAGAN WILLIAM GAMBINI GERRY GARSTON JOHN GRILLO PHILIP
GUSTON BURTON HASEN DOROTHY HELLER HANS HOFMANN ANTHONY
IPPOLITO REUBEN KADISH ARISTODEMOS KALDIS MATSUMI
KANEMITSU EARL KERKAM FRANZ KLINE RICHARD KLIX AL KOTIN
STANTON KREIDER JOHN KRUSHENICK GEISHA KURAKIN ISRAEL
LEVITAN WILLIAM LITTLEFIELD VINCENT LONGO BORIS LURIE
MARCIA MARCUS STEVE MONTGOMERY GEORGE MORRISON DOROTHY
MULLER CONRAD MALLICOAT RAY PARKER FELIX PASILIS EARL
PIERCE MILTON RESNICK A SCHLEMOWITZ THERESE SCHWARTZ
WILLIAM SEBRING SALVATORE SIRUGO RONALD SLOWINSKI NORA
SPEYER RICHARD STANKIEWICZ MYRON STOUT ANNE TOBACHNICK
IRWIN TUTTIE RUTH VODICKA SAM WEINER FLORENCE WEINSTEIN
ROCCO ARMENTO ANNE ARNOLD RONALD BLADEN ILYA BOLOTOWSKY
LEE BONTECOU WARREN BRANDT J ANTHONY BUZZELLI JEAN CLAD
EDWARD CLARK ROLLIN CRAMPTON JANE BRASWELL CRAWFORD
JACK DAVIS WILLEM DE KOONING ROBERT DE NIRO GEORGE
DWORZAN JOHN FERREN MILES FORST JOHN FRANK MARY FRANK
SEYMOUR FRANKS WILLIAM FREED SIDEO FROMBOLUTI JAMES
GAHAGAN WILLIAM GAMBINI GERRY GARSTON JOHN GRILLO PHILIP
GUSTON BURTON HASEN DOROTHY HELLER HANS HOFMANN ANTHONY
IPPOLITO REUBEN KADISH ARISTODEMOS KALDIS MATSUMI
KANEMITSU EARL KERKAM FRANZ KLINE RICHARD KLIX AL KOTIN
STANTON KREIDER JOHN KRUSHENICK GEISHA KURAKIN ISRAEL
LEVITAN WILLIAM LITTLEFIELD VINCENT LONGO BORIS LURIE
MARCIA MARCUS STEVE MONTGOMERY GEORGE MORRISON DOROTHY
MULLER CONRAD MALLICOAT RAY PARKER FELIX PASILIS EARL
PIERCE MILTON RESNICK A SCHLEMOWITZ THERESE SCHWARTZ
WILLIAM SEBRING SALVATORE SIRUGO RONALD SLOWINSKI NORA
SPEYER RICHARD STANKIEWICZ MYRON STOUT ANNE TOBACHNICK
IRWIN TUTTIE RUTH VODICKA SAM WEINER FLORENCE WEINSTEIN
ROCCO ARMENTO ANNE ARNOLD RONALD BLADEN ILYA BOLOTOWSKY
LEE BONTECOU WARREN BRANDT J ANTHONY BUZZELLI JEAN CLAD

SPRING INVITATION

THE NONAGON 99 SECOND AVENUE

OPENING TUESDAY MAY 12 5 - 10 PM

MAY 12 - JUNE 4 1 - 10 PM

GRAMERCY 5-5232

3. Co-Existence Bagal Shop
4. Copper Lantern
5. Des Alpes
6. Iron Pot
7. Koe's
8. La Bodega
9. Mike's Pool Hall
10. New Pisa
11. New Tivoli
12. Old Spaghetti Factory
13. Opus One
14. The Place
15. Red Garter
16. Shanty Malone's
17. Tea Shoppe & Coffee Gallery
18. Tao Lee Yon's
19. Vesuvio's
20. William Tell Hotel
21. Yee Yun's

LOW